COLORADO
LEGENDS & LORE

THE PHANTOM FIDDLER, SNOW SNAKES AND OTHER TALES

STEPHANIE WATERS

Charleston · London

THE
History
PRESS

Published by The History Press
Charleston, SC 29403
www.historypress.net

Copyright © 2014 by Stephanie Waters
All rights reserved

Front cover, bottom: Sky Pond image courtesy of Mike Scalisi.

First published 2014

Manufactured in the United States

ISBN 978.1.62619.481.6

Library of Congress CIP data applied for.

To the last man standing

CONTENTS

ACKNOWLEDGEMENTS

I was thrilled and honored to write this book. Thanks again to The History Press, especially to commissioning editor Becky LeJeune, copyeditor Ben Ellenburg and the rest of the production team. Big thanks to friends and family, including my buddy Vanessa "Rita" Dolbow, who contributed illustrations, and my cousin Des "Desperado" Matthews, a professional artist. Even my late grandmother Mary Bryan Waters posthumously furnished artwork. My appreciation goes to Grandpa, Alpha Dog and Ranee Langlois for technical support. I'd especially like to honor my fellow haunted history tour guides: Dean Weiler in Aspen, Gail Westwood in Breckenridge, Canon City Ghost Tours, Eric Bloomfield in Central City, Lori Juszak in Fort Collins, Dori Spence in Longmont, Roger Pretti in Leadville, Joel Chirhart in Morrison and Haunted Corazon Ghost Tours in Trinidad. Special thanks to the Cripple Creek Lawman and Jail Museum, Colorado Grand Casino, the Saint Nicolas Hotel, Glenwood Spring's Colorado Hotel, the Stanley Hotel in Estes Park, Central City Historical Society, Century Casino, Easy Street Casino, Reserve Casino and the George Rowe Museum in Silver Plume. I'd like to salute author Linda Womack and Ute Pass historian Jan Pettit (whom I always admired and met through writing this book). Thanks to the many folks I interviewed, including All Girl Paranormal Society; Boulder's Spiritbear; Laura Westfall; Craig Cristophel; Michelle Mayer; Donnie Reed; the Spirit Chasers; Erica Leonis; Mike Coletta; Kris Tennatt; Wesley Waters; Darin Waters; Brett Leal; LeeAnna Jonas; Linda Volkens; RMRIPP; Devil's Head forest ranger Billy Ellis; the forest ranger at Crack Cave; Judy at the UFO Watchtower; Pueblo's Immortal Solstice dance troupe; Mr. Erik

Swanson in Fairplay; and Mr. George Coal, who treated me to a private tour of the statehouse on my fiftieth birthday. I'd also like to acknowledge the Gilpin County Historical Society, the Cripple Creek Victorian Society, Pikes Peak Library District, the Visual and Performing Arts Department at the University of Colorado–Colorado Springs and the Colorado Springs Evergreen Cemetery Benevolent Society, Siddhartha, Mary Jane and Monkeys. Most of all, hats off to the historians who fostered preservation of our state's fascinating heritage.

INTRODUCTION

Old-timers claim that once you've hung your hat in Colorado, it will always be home, no matter where you later roam. Colorado becomes a part of you, like the crystal-clear mountain waters we drink and the fresh air we breathe. Its indelible legacy is emblazoned in the red dirt beneath our feet and stained by the blood of proud Native Americans and pioneers. My passion for our state's mysteries began when an elementary school teacher told our class a strange story that greatly influenced me. Mr. Borst said that in the mid-1970s, he and some friends were hiking in the mysterious San Luis Valley, when they spied several spaceships hovering over the Sangre de Cristo Mountains. Furthermore, he claimed that unexplainable aircraft had been documented in the valley since the Spaniards first explored southern Colorado in the sixteenth century. Mr. Borst reasoned that they might have been camping near an ancient UFO landing strip! Then he launched into a lackluster astronomy lecture. We begged him to skip the small talk and tell us more about the UFOs, but he adamantly refused, joking that he wanted to see his name, and not ours, in the newspapers for making the discovery. He quipped, "There is much more in the world that we don't understand than do."

Those intriguing words might have been what inspired me to become a rocket scientist, but I settled for being a professional storyteller instead. I had always dreamed of writing, so it was a godsend when The History Press made me an offer I couldn't refuse. Much to my delight, *Haunted Manitou Springs* was a huge success! Dozens of copies flew off the shelves, and I laughed all the way to the bank. Inspired by my success, I followed with two

more blockbusters. Needless to say, I was perfectly content resting on my literary laurels, until fate threw the dice of destiny.

In the charming town of Salida, I spied a crumbling structure teetering on a mountainside and was curious about its origins. A waitress at the Boathouse Café claimed it was an ancient mausoleum for a duke. Say what? European royalty buried on a mountaintop above Salida? This I had to see. After lunch, I hiked to the monument but didn't find the answers I hungered for. Intrigued by the mystery, I did some research and found an amazing story behind the lofty shrine. The titillating tale got me to thinking about local legends and lore; however, I was disappointed when I couldn't find much on the subject. I imagined a narrative book of short stories about treasure tales, tall tales, unsolved mysteries, holy miracles, local lore, Indian legends, folklore and ghost stories all rolled into one big enchilada—in a nutshell, sugarcoated history.

After The History Press gave the green light, I began a thrilling yearlong journey of research and discovery. I thought it was hilarious that legislators seriously considered naming our state "Lu Lu!" I also learned that many different flags have flown over our land. Colorado has belonged to the Pueblo people, American Indians, Mexicans and Texan land-grant companies, as well as both Spain and France. Once trapping and prospecting came along, they brought hopeful adventurers from all over the world. It wasn't long before storytelling became an integral part of bonding and creating culturally diverse legends.

All of the stories in this book are about places that you can actually visit. After all, Colorado legends aren't usually posted on signs, so reading this book will make you look like a smarty-pants in front of your campfire friends. Furthermore, most of these tales have only been written about in old newspapers. With the more familiar legends, I dug deeper into historical archives and found some really interesting details that were somehow overlooked before. I also included original newspaper headlines and quotes whenever possible because they are amusing and prove that the stories are based on facts. For example, on December 29, 1916, headlines in the *Akron Weekly Pioneer Press* screamed: "GLASS EYE EXPLODES AS HE LOOKS AT PIE!"

Needless to say, sometimes I laughed myself silly. But it wasn't just the kooky headlines that caught my eye. I was amazed to find bizarre tales like the one about a time warp tunnel discovered near Estes Park and another about a ghost that haunts an entire town. Now, how's that for an exciting cliffhanger? Calling myself the "Galloping Historian," I went on several

road trips for research purposes. Especially entertaining were the haunted history tours, where local guides were happy to share tainted tales of mystery and mayhem that still have me sleeping with the light on! So fasten your seat belts, my friends, it's going to be a thrilling ride. I sincerely hope you enjoy reading this anthology as much as I did researching and writing it for your pleasure. Happy trails!

1

COLORADO CRITTERS

CABIN FEVER (MOUNT SNEFFLES AND OURAY)

The best-laid plans of mice and men
Go oft awry.
—*Robert Burns*

Back in olden times, cabin fever was no joke. It was a madness brought on by isolation during long, lonely winters. The horrific malady came on slowly and caused strange hallucinations. Sadly, many a mountain man succumbed to the fever, likely because the allure of riches seemed well worth the risk. Such was the case with Old Clint, who long ago built himself a rustic cabin on Mount Sneffles. His humble abode was built over the mouth of his mine so that he could dig even in the dead of winter. The mining hut was made out of rock, blood, sweat and tears. An old cast-iron stove was used to cook his simple meals of beans, barley and whatever else he could kill with a gun and throw into a pot. A simple kitchen table was made from a plank board supported by two powder kegs. Near the back wall was a horsehair mattress that lay flat on the dirt floor next to a couple rickety chairs. The crude cabin wasn't much to look at, but Old Clint was happy as a clam. His nearest neighbor, Mr. Jones, lived only two miles away, but Clint didn't get

to see him very often. Yet every once in a blue moon, the mountain man would get a hankering for company, so he would mosey on down to Porter's General Store, about four miles down the mountainside. Winter comes early in the San Juan Mountains, and by October, Old Clint was usually snowed in until spring thaw. The winter of 1870 was particularly cruel, and by mid-September, the old-timer was already mighty lonely for company.

Mercifully, his prayers were answered when, on Christmas morning, he spotted a fly buzzing around his cozy cabin. The old man thought it mighty peculiar that a housefly was alive in midwinter, and even stranger was that the insect was buzzing "Jingle Bells"! After all, that was his favorite Christmas tune. Clint was a sentimental old fool, so to celebrate the grand occasion, he made a little stool for "Fred" out of a sugar cube that he set on his kitchen table. By candlelight, the twosome enjoyed a hearty Christmas dinner, which they washed down with Clint's homemade dandelion wine. Understandably, it wasn't long before man and fly became best buds. Clint enjoyed playing his fiddle for the fly, and the little insect danced merry jigs to happy tunes. Clint taught Fred how to play board games—chess seemed to be his favorite. The insect loved whiskey, but unlike common barflies, Fred could hold his liquor. Sad to say, but the little critter often drank Old Clint right under the table! But in the old man's feeble mind, Fred the fly was the best friend he'd ever known, likely because he didn't bug him. The bosom buddies dreamed of doing lots of sporty things together, like hunting and fishing. Sometimes Clint shamelessly teased that a juicy fly would come in handy at the lake. Yet they say "the best-laid plans of mice and men / Go oft awry," so it was rather ironic when fate soon intervened between insect and man.

One sunny morning in early spring, Old Clint was surprised as hell when his neighbor came knocking on his front door. Come to find out, just before winter set in, Mr. Jones had purchased two long, skinny sleds, which he called Norwegian snowshoes. Old Clint was overjoyed to see his old pal and had him pull up a chair to the kitchen table while he made a pot of hot coffee. Fred was nowhere to be seen or heard, so Clint just assumed his little buddy was sleeping off yet another one of his nasty hangovers. The neighbors had a riotous time swapping yarns and playing chess. But all the laughter, hooting and hollering finally woke Fred, so he buzzed over to his sugar cube to observe the exciting game in action. At first, the old-timers didn't take notice of the little guy. But as the game progressed, Fred typically couldn't hold his excitement, so when Old Cliff declared checkmate, Fred buzzed a victory cheer! Suddenly, Mr. Jones noticed the annoying spectator, and he was so angry about losing the game that he smashed the trespasser with his

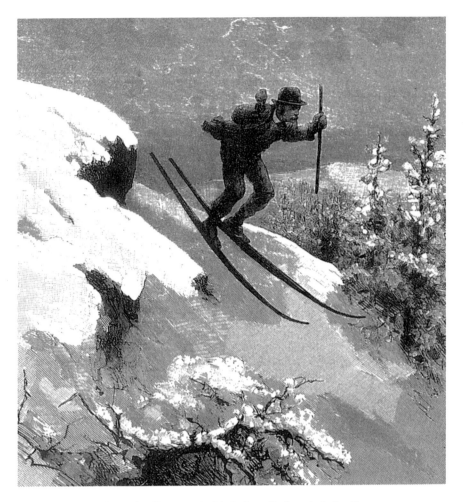

Clint skied down Mount Sneffles to make his dark confession. *Author's collage.*

fist. Needless to say, Old Clint was flabbergasted that Mr. Jones killed his one and only pet. Without thinking, he grabbed his nearby shotgun and blew the fool's head off, and then cried like a baby at losing the two best friends he'd ever known. Clint never read much, but he knew his grief was epic and that the great Bard himself couldn't have written such a sorrowful Shakespearean tragedy.

The next morning, Old Clint borrowed Mr. Jones's snowshoes (since he wouldn't need them anymore) and skied his way down to Porter's General Store to make his terrible, dark confession. After Clint tearfully told about the close friendship that was forged between him and his pet fly, the jury

of six burly mountain men shed plentiful tears, knowing all too well the pain of isolation and loneliness. They also knew that any man who could befriend a pesky little housefly had to have a heart of gold. The decision was unanimous: Old Clint was found guilty of justifiable homicide and released with just a slap on the wrist. Shortly thereafter, folks felt sorry for the lonely old man, so they brought him a stray dog to keep him company. Despite their good intentions, Old Clint didn't take a liking to the mangy mutt and instead preferred the friendship of its many fleas.

Years went by, and eventually, Old Clint was found frozen to death on Mount Sneffles. He was buried in Ouray's Cedar Hill Cemetery, side by side with his old neighbor, Mr. Jones. Crazy as it might seem, until his dying day, Old Clint lamented his little buddy Fred and often told how the best friend he ever had was a common housefly with a drinking problem.

THE DEARLY DEPARTED
(CRIPPLE CREEK, FRUITA AND SALIDA)

And fragrant is the thought of you
The file on you complete
Except for what we forgot to do
A thousand kisses deep.
—*Leonard Cohen*

Throughout Colorado, you will find statues and monuments honoring the dearly departed. Some of these shrines and tombstones are very elaborate. Obviously, a few old-timers spent a pretty penny immortalizing the memory of their loved ones. This was certainly true with a wealthy whorehouse madam known as Cripple Creek Sally. After one of her beloved studs suddenly died, the hooker with a heart of gold paid big bucks to have Romeo properly buried in Mount Pisgah Cemetery. During the fancy funeral service, Madam Sally lamented that only the good died young. Little did she know that dying at thirty was old—for a horse. But it wasn't just Sally's Riding Academy that honored departed critters. An old-timer in Fairplay loved his jackass Prunes more than life itself, so in death, man and beast were buried side by side. Their impressive tombstone is encased with loving photos along with Prune's bridle. The extraordinary monument is still located on Front Street and was mentioned in *Ripley's Believe It or Not!* Trumping the jackass was a famous

Salida's shrine to Duke the dog is not what it once was. *Author's photograph.*

Colorado critter that received an honorable nod in the *Guinness Book of World Records*. The crazy story goes that in 1946, a farmer in Fruita planned on eating one of his yardbirds for Sunday supper. But when Mr. Olsen chopped off the rooster's noggin, a portion of his brain stem remained intact and the bird lived! The frazzled farmer christened the amazing wonder "Mike the Headless Chicken," and then the dynamic duo hit the road with a crazy stage act. The funky chicken dazzled peeps all across the country, making Mr. Olsen a lot of "chicken feed" before he was finally taken by the "Grim Peeper" two years later. Mike was memorialized with a bronzed statue of his likeness that still stands in Fruita…albeit headless.

The town of Salida has honored a special pet for over a century. The sappy saga began long ago, when a lonely hotel owner named Mr. Catlin found a scruffy puppy living among a pack of mad dogs. The fleabag was a raging terror at first but soon warmed to Catlin's loving care. They say that stray dogs, once given a happy home, are loyal like none other, and so it was with this mangy mutt. Catlin, being an unmarried man, often joked that he was king of his castle, so he thought "Duke" would make a suitable name

for his loyal friend. Although Duke had been mistreated in his former life, he soon loved one and all. Considering his newfound congenial personality, it only seemed fitting that the happy hound worked as goodwill ambassador to Catlin's hotel. Whenever the train rolled into town, Duke could be seen escorting tourists back to the lodge. Catlin often joked that his dog was the best employee he'd ever had—and the only one who ever worked for peanuts. One fateful day, Duke was waiting at the station, when he suddenly spotted a toddler playing on the railroad tracks. The hero hound leapt to his heels and grabbed the baby by its coat just in the knick of time! After the train passed, the child's teddy bear was found on the tracks, flat as a pancake. A crowd of witnesses cheered for the courageous canine. One man even lifted Duke onto his shoulders and paraded the lucky dog throughout Salida like a homecoming hero. Certainly, there was never a dog like Duke, and when he died at a ripe old age, the town of Salida threw a funeral like none other. Flags waved, the high school band played and villagers danced in the streets. As if the pomp and ceremony weren't enough, Mr. Catlin built a colossal tomb for Duke on top of Tenderfoot Mountain! Believe it or not, the monument rivaled India's Taj Mahal, which was also a great tomb built by a besotted mourner for his beloved. On September 27, 1903, the *Denver Post* featured the amazing story and intriguing photograph of Duke's mausoleum with the curious headline:

ERECTED COSTLY MONUMENT
TO THE MEMORY OF HIS DOG

The amazing shrine was composed of the same elegant Colorado marble used for national monuments in Washington, D.C. There was even a canopy supported by four ornate Corinthian columns and a pink granite nameplate engraved with a sentimental epitaph. Picnic tables were set around the tomb that afforded a sweeping view of the village below. Although ravaged by time, the crumbling mausoleum serves as a charming reminder of the oddest funeral Salida has ever seen and of the love one town had for its heroic wonder dog. Incidentally, the village of Fruita still honors Mike the Headless Chicken with an irreverent festival held every spring. Fruitonians enjoy doing the chicken dance, serve scrambled eggs and eat buckets of fried yardbird. It just goes to show that folks in Colorado still know how to honor their dearly departed critters.

Bad News Bears
(Glenwood Springs, Leadville and Telluride)

The trouble with trouble is that it always starts out like fun.
—Yogi Bear

No doubt about it, bears enjoy dumpster diving and plundering for spoils. In Manitou Springs, I once witnessed a rogue bear squeeze through the window of a Honda to steal the remains of a forgotten picnic lunch. The happy bruin sat curbside, contently devouring a bucket of chicken bones and a bag of stale Cheetos. He celebrated his good fortune by chugging down fruit punch and smashing the carton like a champagne flute! A half a block later, the party animal found dessert in an apple tree and then happily waddled over the hillside. Most people don't seem to be afraid or concerned about the wandering marauders, knowing that if you leave a bear alone, he will usually extend the same courtesy. However, in the last century, bears were a real menace to society, especially the enormously threatening grizzly bear. They were known as man-eaters, and old-timers claimed that once a grizzly tasted human blood, he'd desire no other. Old Mose became a legend in his own time, after folks became aware of his enormous appetite, size and intelligence. With his beady brown eyes, the devious villain would hypnotize his unassuming prey. Once the hunter became the hunted, Old Mose would devour the poor soul. Needless to say, there was seldom anything left after the brutal attack except shredded clothes and an unsightly wet spot. Many attempted to put an end to the bear's bullying, but only a few lived to tell about it. Old Mose killed at least twenty men, one thousand deer and hundreds of cattle before Moccasin Bill sent him to his maker. The mountain man certainly earned locker-room bragging rights—especially since the hairy hide of Old Mose measured over ten feet in length. A professor at Colorado College examined the thousand-pound beast and found Old Mose had an unusually large brain, which could account for his uncanny smarts. Today, grizzly bears are on the endangered species list. But hopefully, environmentalists won't petition to get the terrifying beast reintroduced in Colorado as they've already successfully done with the dreadful Preble mouse or yellow-bellied mountain flea.

However, the great grizz was not the only beast that terrified folks. Long ago, an innocuous bear found in Glenwood Springs caused pandemonium that spread like wildfire throughout the world! According to the Colorado Hotel, it all began in 1905, when President Theodore Roosevelt was its honored guest while hosting a hunting expedition near the hot springs resort

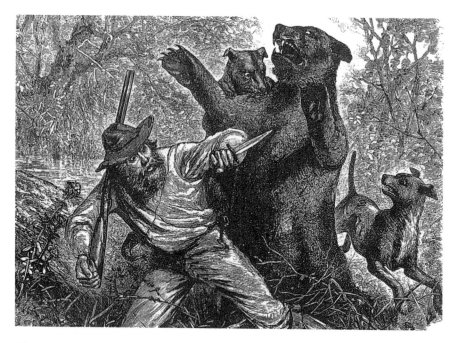

Moccasin Bill settled the score with Old Mose. *Author's collage.*

town. (Even though Teddy was a rough rider, he wasn't really roughing it.) Reporters patiently waited with loaded cameras and sharpened pencils hoping for a front-page news splash. However, weeks went by, and Teddy never bagged a bear. Then, on the final day of his trip, a thoughtful hotel maid fashioned a little toy bear out of rags and offered the stuffed animal to the famed hunter as a consolation prize. A legend was born when Roosevelt's young daughter embraced the charming toy and joyfully exclaimed that she would call him "Teddy bear." The toy became an overnight sensation, and manufacturing companies quickly capitalized on the high demand. Soon, the industry began inventing new products to compete with the popular toy. But January 20, 1907, looked like doomsday for the teddy bear, when the *Leadville Carbonate Chronicle* announced that the "Fido muff" had taken the teddy's place. The stuffed animal hand-warmers resembled a pet poodle and even came with a darling rhinestone collar. To wear the muff, a child's right hand would be thrust into Fido's mouth and her left hand into the poodle's— well, you get the rather unflattering picture. Needless to say, this thoughtless design flaw was likely the reason why the Fido muff never caught on, and the teddy bear reigned supreme in the stuffed animal kingdom. Since allowing

children to play with naked bears seemed improper to Victorian sensibilities, costuming teddies soon became all the rage. Girls and boys delighted dressing in frilly dresses and sailor suits, to match their toy bears. Elite teddy bear tea parties were all the rage at posh resorts and fine hotels. In the beginning, it all seemed like innocent child's play; however, it wasn't long before things got really ugly. Spoiled children threw temper tantrums over who had the best-dressed bear, and battles often resulted in horrific injuries. Sadly, it wasn't uncommon to see battered teddies wheeled around in strollers with severed arms, legs and heads. As if noticing these raggedy tug-of-war veterans wasn't disturbing enough, many girls rejected their delicate, refined china dolls in favor of the roguish, button-eyed teddy! Then alarming news ruffled a few feathers when front-page headlines for the *Summit County Journal* screamed:

TEDDY BEARS MEAN RACE SUICIDE

In the article, Father Michael G. Esper of the prestigious Saint Joseph's Catholic Church in Missouri vehemently exclaimed:

> *There is something natural in the case of a doll and a little girl; it is the first manifestation of the feeling of motherhood. In the development of these motherly instincts lies the hope of all nations; it is a monstrous crime to do anything that will tend to destroy these instincts. That is what the Teddy bear is doing and that is why it is going to be a problem if the custom is not suppressed. It is terrible enough that the present generation of parents in the country are leading us into grave danger by the practice of race suicide. If we cannot awaken them, let us at least save the future generations.*

To make matters worse, a Mrs. Gilson publicly agreed with Father Esper's astute observations, and many parents took notice—especially since she was the president of the National Congress of Mothers. Then, the fur flew in Telluride after the men's high school basketball team embarrassed the entire state by introducing the emasculating teddy bear as their official mascot. Headlines for the *Daily Journal* shouted:

*TELLURIDE HIGH SCHOOL BASKETBALL TEAM
HAS A TEDDY BEAR MASCOT!*

Many Americans believed that social values in Colorado were going to hell in a handbasket, and no doubt, the rotten teddy bear was to blame.

The *Leadville Carbonate Chronicle* added to the hysteria by announcing grisly front-page news that the beloved teddy bear was responsible for spreading infectious disease! During an all-out witch hunt, a physician discovered that while hospitals routinely incinerated disease-infected bedding, personal items like a child's beloved teddy bear often escaped the fateful furnace. He wisely surmised that a sick child's teddy bear could be to blame for inadvertently killing thousands of unwitting victims. After the startling announcement, disgraced teddy bears all over the country were burned at the stake. When sales for the teddy bears plummeted, toy companies tried to save face by getting good publicity for the little rascal. For example, when five-year-old Grace Mower fell from a second-story window and safely landed on her teddy bear, the miracle made newspapers all across the country. Then, when Mr. Albert Degler ran over his bear-hugging child, headlines in the *Haswell Herald* exclaimed that the stuffed animal shielded her from the wheel. The ingenious publicity campaign was a big success, and the teddy bear redeemed itself as a hero! After a century of trials and tribulations, the teddy bear has certainly earned its stripes and is still regarded around the world as a time-honored toy. The Colorado grizzly bear, however, will never be welcome back in my neck of the woods!

SUPERNATURAL MYSTERIES

FOUNTAIN OF LOVE (TELLER COUNTY)

Love is the tie that binds.
—Anonymous

It's too bad that Ponce de Leon never ventured farther than Florida in search of the legendary fountain of youth, because a better magical spring was found right here in Colorado. Long known as the Fountain of Love, its secret location has been kept tightlipped…until now. But before I spill the beans, please allow for a brief history lesson about Colorado's treasured mineral springs.

Native Americans have long held that the bubbly waters were sacred gifts from the gods and greatly valued their curative powers. In fact, the Utes believed that the Great Spirit lived beneath the earth and that his breath made the waters bubble up from the ground. In the late 1800s, thousands of tuberculosis patients flocked from all over the county seeking the cure, as a combination of spring water and a dry climate was the only known remedy. Competition between burgeoning resort towns became fierce, and it wasn't long before they began using clever gimmicks to attract customers. Both Ouray Hot Springs and the Manitou Bath House advertised the amazing health benefits of drinking and bathing in radium-riddled waters. This announcement came after miniscule amounts of the carcinogen were found in the waters. But the oddest story about the health benefits of a magical mineral spring concerns Teller County.

The story begins in a ghost town known as Love, which was located not far from the present-day mining town of Victor. However, all that remains of Love's former glory is its romantic name, an indelible mystery and a treasured secret. The rural hub was nestled at the foot of Cow and Sheep Mountains, where the grass grew thick on the banks of the rippling Beaver Creek, antelope played in green meadows and songbirds tweeted in treetops. It was an ideal location for ranchers and dairy farmers, who greatly benefitted from the rolling green hills and bubbly spring water. The utopia was founded by Charles Love, a prosperous cattleman who was one of the first to settle in the area before mining took hold. The town had a post office, dairies and sawmills and was also a stop for the Short Line Railroad. Suffice it to say that the idyllic village could have been the inspiration for a Norman Rockwell painting. Sadly, paradise was lost when folks noticed that their cows were producing only male offspring. Needless to say, it's utterly impossible to run dairy farms without udders. Folks were flabbergasted after realizing a female had never been born in Love. Many wondered what could be causing this perplexing problem in the little town but were likely too embarrassed to talk about such delicate matters.

Mr. Beard was a boxing promoter for Teller County and macho father of nine burly boys. Although the country bumpkin didn't have much book learning, he had the Midas touch when it came to recognizing a knockout business deal. One fine day, opportunity punched him in the face when he overheard a curious conversation at the post office. Apparently, after eleven dazzling daughters, the Russian emperor was desperately hoping for a male heir. Since the town of Love had plenty of feisty young bucks, Mr. Beard came up with an ingenious plan. With the assistance of the postman, he composed an inspiring letter explaining the abundance of healthy males born in the town. He then sent the encouraging memo along with a case of magical spring water directly to Russia, with love. Lo and behold, just nine months later, the emperor's wife produced a bouncing baby boy. When asked how he discovered the unconventional solution, Mr. Beard boasted that a healthy libido was easily gained by simply drinking the elixir of Love.

Miraculously, this nectar of the gods didn't just invigorate sexual prowess, but it also fostered hair growth! The ingenious entrepreneur observed that all the males in town had resplendent, full heads of hair. In fact, his three-year-old was already proudly sporting chest fur! The waters of Love were found to be the perfect elixir for balding men and for frazzled cowboys needing "giddy-up" in the bedroom. Mr. Beard planned on bottling and selling the mystical waters for a nifty profit. Sadly, his pipe dream soured like spoiled

The Fountain of Love. *Author's photograph.*

milk after a mysterious jinx fell upon the little community. Headlines for the *Aspen Daily Times* screamed:

A WEIRD MYSTERY HANGS OVER THE TOWN OF LOVE
THREE DEAD BURROS, COATS OF MAN AND WOMAN
FOUND ON SHEEP MOUNTAIN

Worried citizens somehow attributed the mystery to the fabled waters, alleging that the bubbly spring had become tainted by some kind of freaky hoodoo Indian curse. Needless to say, the blessings of Love were also its undoing, and now the town is nothing more than an ominous footnote in history books. But a few old-timers in the know still partake of its magical waters and are as healthy as jackrabbits. Needless to say, the mineral spring's hidden location is a well-guarded secret. That's why if you ask locals where to go to drink from the "divine cup," I guarantee they'll look at you like you're crazier than a one-eyed bed bug. They say that with great power comes tremendous responsibility, and folks don't want fools abusing the magical elixir like they once

did. But I'll give you some hints. The Fountain of Love is still found at the foot of Cow and Sheep Mountains, where the grass grows thick on banks of the rippling Beaver Creek. Look for antelope romping in green meadows and listen for songbirds tweeting in treetops. Keep in mind that those lucky few in Teller County who still sip from the sacred hole are easily recognized by the happy skip in their step, devilish glee in their eye—and lots of fur!

Killer Caves and Teen Spirit (Rico and Red Cliff)

Only the good die young.
—*Billy Joel*

Campfire tales warning of evil caves were quite prevalent in the olden days. Perhaps the most fearsome was the Devil's Den, located near the old ghost town of Rico. The official body count of victims still laying in the bottomless pit is unknown. But the first documented case of death in the underworld was recorded in 1891.

The story begins with Miss Carrie Neal, a pious preacher's daughter who was cuter than a speckled pup under a little red wagon. It was no secret that every buck in town desired to be her beau. Her next-door neighbor was a handsome ranch hand Romeo, but he was just about as worthless as a pail of hot spit. Frank Howard was often teased for being the nervous sort and taunted by chants of "Howard the Coward!" How he got to be a cowboy was anyone's guess, since he was the sort of fellow who was afraid of his own shadow. Yet the redneck Romeo was suffering terribly from "Cupid's cramps" and desperately wanted to win the affection of Miss Carrie Neal. To show her that he was a thinking man, Frank quoted pearls of outhouse wisdom from the genius of Browning, Keats and Sears and Roebuck. When that trick failed, he romanced the fair maiden by strumming tender ballads on his ukulele, yet nothing gained her attention.

One fateful day, the young man heard about an evil cave inhabited by the devil himself, and to grab a rock from inside the cavern during the full moon was said to bring good luck. Frank believed that if he could master this noble feat, he would win the heart of his ladylove. News of Frank's idea to slay the dragon soon reached Miss Carrie, and she was thunderstruck! Cupid's

arrow had pierced the maiden's heart, and for the first time ever, the bashful babe took notice of the slick hick. Bowled over by his brave conviction, the preacher's daughter agreed to accompany the pretty boy on the exciting adventure, yet she was adamant that she wouldn't be entering the fearsome Devil's Den.

Three days later, Frank Howard, Miss Carrie and a few of their friends secretly met in the churchyard at midnight. With flaming torch in hand, not a word was spoken as the youths crept quietly out of town. But once the party gazed into the yawning abyss, Frank lost his nerve...and his lunch! To save face, the coward suggested venturing into the darkness as couples. But before anyone could argue, Frank grabbed Miss Carrie's sweaty hand and charged into the devil's mouth swinging his walking stick like King Arthur wielding Excalibur! Inside the hellish dungeon, the teens eased their collective fears by cracking jokes. But perhaps they teased too soon, because just then, the cave shuddered and belched odious clouds of smoke. The preacher's daughter shrieked before fainting into Frank's arms, but the yellow-bellied coward of Rico dropped his fair maiden like a hot potato and bolted like a bat out of hell! Once the others caught up, the cad looked around and realized he was the only stag at the party! Howard the coward was so embarrassed by the yellow streak running down his back that he ran home crying like a little schoolgirl. Yet chivalry was not dead because the other boys grabbed the torch and dashed back inside the hellhole to rescue the damsel in distress. Sadly, just footsteps from the entrance, they found Miss Carrie deader than a doughnut. In July 1891, the sad news was covered from coast to coast, and a headline in the *Daily Illinois State Journal* said:

IN A POISONED CAVE
A Young Girl Loses Her Life While Investigating Its Mysteries

To this very day, the evil Devil's Den is still known to folks living around Rico, but they have sense enough not to venture within its poisonous grasp.

Perhaps the most mysterious cave was known as the Widow Maker. The haunted hole was discovered near Red Cliff in 1869, when a hunter was tracking a deer. The young man could track a bear through running water and bees through a blizzard yet was completely mystified when the deer's tracks abruptly stopped on top of a ridge. It was as if the doe had been sucked into the clear blue sky! Perplexed by the mystery, the youth sat down on a nearby rock and enjoyed jackrabbit jerky while chewing stupefied thoughts.

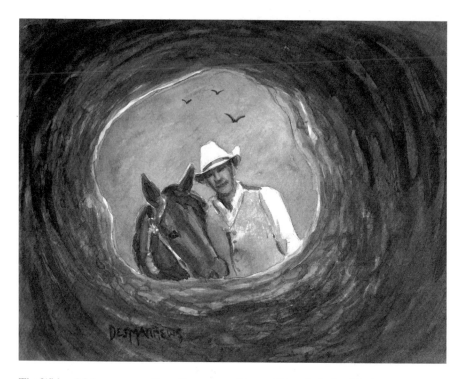

The Widow Maker cave was feared by man and beast. *Watercolor by Des Matthews.*

Suddenly, he heard a desperate yelping from his loyal watchdog. The bewildered teenager called for his mutt and patiently listened for plaintive howls, but all he heard was the painful reality of silence. The young man was understandably mighty spooked by the thought of innocuous animals instantly vanishing into thin air. Shaking like a leaf, he hastily grabbed his mule and turned to head home while the getting was good, but the terrified nag refused to budge. Just then, he spied an obscured cave peeking from behind a border of scrub oak. Oddly, fresh drag marks in the snow led directly into the dark hole. To add to the puzzling mystery, dozens of white bunnies began flying through the air as if they'd sprouted wings! Within seconds, the wide-eyed rabbits were sucked into the yawning mouth of the cavern, one by one like popcorn kernels!

When the spooked kid returned home, he told of his mysterious experience and warned others not to venture near the voracious vacuum. However, folks didn't pay much attention to his crazy story because he was well known for telling whoppers. Ironically, his tragic demise came to be like the boy who cried wolf, because shortly thereafter, he also disappeared.

Years later, the Denver and Rio Grande Railroad blazed through the peaceful valley, and the Rockwood Station was located not far from the Widow Maker. It wasn't long before the man-eating cave gained local notoriety and the Rockwood Station became a popular stop on the railroad line. However, on October 16, 1891, the Widow Maker gained national attention when headlines for the *Jackson, Mississippi Citizen Patriot* warned:

PUFF AND OUT THEY GO.
A Cavern in Colorado That Resents the Intrusion of Strangers

After the spit hit the fan, a group of brave young explorers set out to defy the Widow Maker's menacing reputation. But when the team captain reached the mouth of the cave moments before the others, he instantly vanished before their very eyes. Before venturing into the menacing abyss, the teens mumbled a quick prayer, linked arms and crossed their fingers. Mysteriously, their fearless leader was heard inside the hellhole, gasping for air, and was found lying on a pile of mangled animal carcasses. Luckily for him, the stinking pile of rotting flesh broke his fall and saved his life. Dazed and confused, the young man had no account of how he landed on the disgusting bed of bones. Thankfully, the frightening experience spawned an investigation. Months later, the *Denver Sun* published an article saying that the Widow Maker's supernatural sucking powers were due to contrasting air temperatures inside and outside the cave. During the winter, cold air was drawn inside, which created a strong vacuum effect. But in the springtime, dirt, rocks and bones spewed from the cave's volcanic mouth like vomit from a college dorm window! But there is a lesson to this cautionary tale: if you happen to stumble upon a mysterious Colorado cave, do not venture inside because the day you do might be your last!

Heaven's Gate
(Alamosa and the San Luis Valley)

To confine our attention to terrestrial matters would be to limit the human spirit.
—*Stephen Hawking*

Mysterious wonders can be found all around the world: Egypt has ancient pyramids, Great Britain is known for Stonehenge and Colorado has the mysterious San Luis Valley.

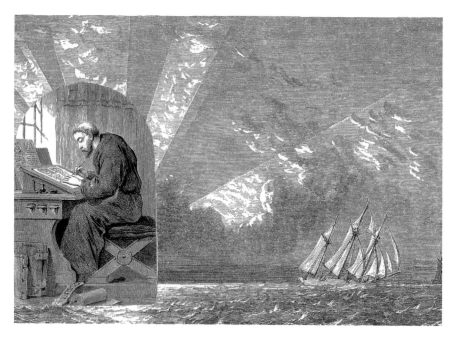

A Spanish monk recorded mysterious happenings in the San Luis Valley. *Author's collage.*

It's no secret that many consider the high mountain desert to be the holy grail of ancient wonders. One of the most mysterious oddities is the Great Sand Dunes National Monument, near Alamosa. Simply put, the mighty dunes are a freak of nature. Over the centuries, global winds whisked billions of multicolored sand granules into the high desert valley. One of the earliest Indian legends tells that a deep hole beneath the dunes drained into the underworld, where evil supernatural beings dwelled. When the Spaniards first explored the valley, they noted many inexplicable oddities, including bizarre flashing lights, and felt thundering vibrations resonating from subterranean depths. Then, much to their dismay, dozens of horses began disappearing from camp. The perplexed soldiers conducted a series of investigations, but searching for animal tracks in shifting sand was pointless. To add to the mystery, they heard chimes ringing and haunting voices whispering in the winds. Three hundred years later, early homesteaders also reported peculiar sounds and witnessed hundreds of ghostly white stallions kicking clouds of dust into moonlit skies. Sometimes ranchers would hold late night rendezvous, hoping to round up the midnight mustangs and break them for a good profit. But attempts to capture them only frustrated the cowpokes, as

their common steeds were never fast enough to compete with the lightning-quick night stallions. Locals wondered how the nocturnal horses could run so fast, unimpeded by the sinking sands. Fortunately, the mystery was solved when a mountain man discovered strange webbed hoofprints stamped in the mud of Medino Creek. He recalled the mystery of the Spaniard's missing horses and figured they'd adapted to their environment by developing webbed hooves!

Some of the spookiest legends about the shape-shifting dunes told of a Mormon caravan being swallowed overnight and the disappearance of the Martinez family. Both mysteries happened in the late 1800s and remain unsolved today. But we do know that the Martinez family consisted of an elderly couple and their teenaged son, Michael, who often grazed their sheep near Medino Creek. Late one afternoon, Michael returned to his adobe shack to find his parents missing without a trace. The frightening experience rendered the youth speechless. After waiting several days for his parents to return, the mute teenager finally went to a neighbor's house with a note in hand explaining the weird tragedy. The ranchers took mercy on the kid by putting a roof over his head. It didn't take long for the couple to forge a close relationship with the pitiful orphan. Sadly, just a few months later, Michael Martinez disappeared while tending their flock near the dunes and was never seen or heard from again. With all the inexplicable disappearances, it's no wonder that the Indians feared the unpredictable moving mountains and never ventured within their menacing shadows.

Celebrated author Christopher O'Brien founded his career on writing about the mysterious San Luis Valley. His books include amazing stories about ghosts, Bigfoot, lost ruins, holy miracles, mysterious gravity-defying roads and hidden treasure. However, he is best known for his expertise in unidentified flying objects, better known as UFOs. Over the past thirty years, O'Brien has documented hundreds of UFO sightings and cattle mutilations in the valley, which he believes are somehow connected. He writes that the area holds several paranormal portals through which extraterrestrials travel and that Mount Blanca holds a secret subterranean air base for grey aliens. (Apparently they come in colors other than green.) Oddly, many ranchers have complained of finding dead cattle with their vital organs dissected with a surgeon's precision. Stranger still is that every drop of blood is drained from the beasts, and radiation is noted, along with peculiar circular burn marks left on the ground. The most famous case occurred on September 9, 1967, when a horse named Lady (but

better known as Snippy) was found mutilated, and front-page headlines from the local *Valley Courier* screamed:

FLYING SAUCERS KILLED MY HORSE!

Just a few weeks later, the Associated Press picked up the story, and the amazing news circled the globe. O'Brien firmly believes that the valley is an epicenter of extraterrestrial activities, and he is not alone. Since the beginning of time, Indians have passed down legends of "winged rock ships" hovering over the valley and of strange lights flickering in the night skies, long before man "sprouted wings."

Perhaps the mysterious heavens are what lured the first spiritual seekers into the valley. In 1850, a small army of Spaniards was camped near the present-day village of Conejos in search of a location for a new mission. But after just a few weeks, they decided to return home. However, a monk's stubborn burro refused to follow the caravan. The frazzled friar kicked the donkey in his flanks, yanked at his woolly mane, screamed in his floppy ears and pulled his lanky tail, but the vapid beast just munched away on wild sweet grass. Finally, the humiliated holy man got down on his knees and prayed for a miracle. After a word with God, the maddened monk sarcastically asked the obstinate beast if they should build a settlement there. As if to agree, the donkey kicked up his heels and brayed at the fine suggestion. In 1854, Our Lady of Guadalupe was erected as Colorado's first church, all because of a stubborn jackass.

Yet another spiritual mystery of the valley has become known as the "Legend of San Acacia." In 1853, Mexican farmers were away plowing in the fields while the women and children busied themselves with domestic responsibilities. As a rapidly moving thunderstorm drew near, a warring army of Indian soldiers barreled toward the village hell bent for leather! When news reached town about the approaching army, a quick-thinking Spanish monk ordered everyone to drop to their knees and feverishly pray to Saint Acacia for a miracle. The skies darkened as the army drew near, and thunder echoed through the farmlands like the bellow of Gabriel's horn. Suddenly, the billowing black clouds instantly vanished from the heavens, and then along came an army of silver-clad warriors darting through the skies! Needless to say, the Indians weren't the only witnesses who ran screaming from the stupendous vision. Historians can't really say what witnesses saw that morning, but villagers called it a miracle. Legend tells that because of God's kind mercy, a church was later erected on the spot. The Chapel of Acacio still stands to this day, the second-oldest church in the state.

So if you are the sort of character who is intrigued by man-eating sand dunes, nocturnal webbed-footed horses, cattle mutilations, holy miracles and UFOs, then you might want to take a trip to the mysterious San Luis Valley. While there, you can learn more about heaven's mysteries by visiting the local churches, temples and shrines, as well as the infamous UFO watchtower.

LAND OF GIANTS AND THE LITTLE PEOPLE (LAS ANIMAS, WOODLAND PARK AND MESA VERDE)

The eyes of that species of extinct giants, whose bones fill the mounds of America, have gazed on Niagara, as ours do now.
—*Abraham Lincoln*

Colorado was once home to some really freakish life forms. Evidence of prehistoric monsters can be found at the Dinosaur National Monument as well as the Florissant Fossil Beds National Monument. But what you probably don't know about our big backyard is that the oddest collection of humongous fossils came from humans!

In 1870, the *Rocky Mountain News* published an intriguing article about gargantuan human bones found outside Las Animas. The distinguished Dr. Beshoar took particular interest in the case. The medical doctor was a proud Civil War hero, a civic leader and the founder of the *Trinidad Advertiser* and *Pueblo Chieftain* newspapers. Suffice it to say that when Beshoar appointed himself as the only suitable authority on such matters as gigantic human fossils, no one argued. On December 20, 1870, the *Rocky Mountain News* quoted the man of science as saying, "The bones are much bigger than any man living today and must belong to a race of giants." According to Richard J. Dewhurst's enthralling book *The Ancient Giants Who Ruled America*, almost every culture on earth included giants at the cornerstone of their beliefs, from the Norse frost giants and biblical Goliath to the Greek and Roman titans. Mr. Dewhurst claims that North America was once inhabited by an advanced earthborn race of giants, which would explain why colossal mummies have been found in several states, including Colorado. The American Indians also had legends about a humongous race. One story told that the great spirit Manitou punished a clan of invading warriors by turning them into the monolithic red rocks found in Garden of the Gods Park. But the natives also shared stories about fairy folk. For example, the Hopi Indians worshipped a tiny benevolent race known as the ant people,

and the Shoshones told of the evil *nimerigar*. However, the most recognized race of fairy folk was the so-called little people. In her enchanting book *Wind Song*, author Mary Summer Rain writes of an unnerving experience with the *little people* that she had outside Woodland Park: "I never dreamed anything like that existed. I mean, as a child, I had picture books about fairies and such, but this was really different. It had no wings. It looked like a miniature Polynesian woman with very large round eyes. Her eyes pierced mine with such a depth that it frightened me." These tiny beings were feared by Native Americans, and settlements of little people were shunned.

When the early pioneers of southwestern Colorado heard legends about little people living in a nearby valley, they scoffed at the silly stories. Imagine their surprise when newspapers across the country confirmed the rumors as being true! On February 23, 1890, a Wheeling, West Virginia newspaper shouted:

THE CLIFF DWELLERS
A REMNANT OF THE MYSTERIOUS RACE
SAID TO HAVE BEEN DISCOVERED IN COLORADO

The discovery of the cliff dwellings occurred in December 1888, when two cowboys were searching for lost cattle in Manassa Canyon. Before heading home, the ranchers dismounted to stretch their legs. At a blustery overlook, the men spit over the edge and took a leak. Obviously, they were a reckless sort, as spitting and peeing are never good things to do over a windy cliff. Suddenly, the clouds mystically parted, and a sunbeam illuminated a gap on the opposite side of the canyon, revealing a miniature kingdom. As the cowboys gawked at the stone village, they wondered who might be staring back at them from dozens of paneless windows. The ranchers rode faster than the wind to the opposite side of the canyon and, with the help of their lariats, lowered themselves over the sheer cliff. Not knowing what or who could be waiting for them, they pulled their pistols before venturing over a rock wall. Not a sound could be heard as they pensively ventured into the long-lost ancient city. It was as if time stood still—clay pots, baskets, primitive stone tools and piles of bones littered the floor—a bonanza of ancient artifacts. The five-thousand-year-old ghost town became known as Mesa Verde.

News of the amazing discovery greatly alarmed Native Americans, who felt it was sacrilegious to disturb the dead. In retrospect, it was a blessing that the Indians made such a fuss because a few greedy opportunists were selling ancient artifacts on the black market. Prompted by outrage, a sheriff from Durango

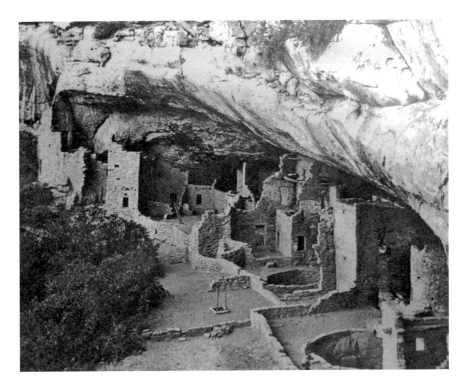

The Cliff House of Mesa Verde. *Author's collection.*

arrested a Swedish aristocrat for attempting to export a third shipment of relics to an overseas museum. But since there were no laws against robbing from dead Indians, he was just slapped on the wrist and sent home without his suitcases. Yet something good did come out of the fiasco, because in 1906, the American Antiquities Act was passed, which outlawed plundering archaeological sites. Yet for years, the Indians still showed contempt over commercializing Mesa Verde. Sometimes their collective disapproval was voiced in the newspapers. On July 28, 1915, headlines for the *Telluride Daily Journal* bluntly stated:

> *DON'T LIKE THE TELEPHONE*
> *Indians Predict That "Little People"*
> *Inhabiting Mesa Verde Cliff Dwellings*
> *Will Destroy Telephone Line*

Supposedly, the little people caused quite a commotion when the park first opened and even a decade later when telephone lines were being installed. Could

it be that the little people were protesting the interactive museum, or was it all just an ironic coincidence? I called Mesa Verde to inquire about the little people and was disconnected. In fact, I never got a return reply. I have to admit it kind of made me wonder if the little people were up to their legendary shenanigans. Or maybe the receptionist just assumed I was munching peyote buttons!

La Muñeca and the Snake People (Walsenburg and Trinidad)

When you see a snake, never mind where it came from.
—Anonymous

Believe it or not, there is a place near the Spanish Peaks where the snakes are so thick you'd have to parade around them on stilts! The vile vipers haunt a cursed rock formation resembling a stone doll, which the Spaniards appropriately christened La Muñeca, meaning "the Doll." One story about the stone giant concerns the Arapahoe princess treasure. Legend tells that when the Spanish mined from their namesake peaks, they discovered more gold than they could possibly cart back to Santa Fe, so they buried the surplus treasure under La Muñeca. The Arapahoe Indians knew of the secret stash but feared going near La Muñeca because it was cursed by legions of vicious vipers. Only the daughter of a great chief knew the exact location of the buried bounty because her late husband was the Spanish captain who hid it there. But it wasn't until the princess was on her deathbed that she told her three grown sons the dark secrets of La Muñeca. With her dying breath, she forbade them to retrieve the hidden riches, reminding them of the evil curse. Come to find out, their father was attacked and killed by legions of slithering serpents while burying bags of gold under the stone demon. The eldest son took after his Spanish father and didn't believe in superstitious nonsense, but he knew the treasure would be his ticket out the door. Under the cloak of a dark moon, the malcontent Indian brave crept to the menacing stone doll. With visions of riches dancing in his head, he reached into a dark hole and felt his salvation, just as his mother had promised. But as the warrior pulled a bag toward the surface, a hungry rattler lunged from its nest and bit off his nose. The stone giant rumbled with laughter, releasing hundreds of vicious vipers. The next morning, the deceitful Indian's brothers grew concerned. Sadly, they found the rebel lying in the vindictive shadow of La Muñeca, staring into the heavens but not seeing a

La Muñeca is a viper pit. *Watercolor/collage by Des Matthews.*

thing. The dead man's eyes were frozen open with a look of absolute terror, and his swollen body looked like a human pincushion. Even to this day, the cursed treasure of La Muñeca is waiting to be found, but nobody wants to go hunting for it because of the deadly curse.

Also haunting La Muñeca were the evil snake people who lived in the dark way of the viper. The few who reported seeing these supernatural beings described them as shadowy, elongated figures shaped in human form carrying sharp knives, spears and tomahawks. These elusive creatures dwelled in underground clusters that were connected throughout the Southwest by subterranean tunnels. Each clan took care of one colossal viper. To ensure fertility of their people, every spring, the firstborn male in a clan would be sacrificed to their serpent king. These viper gods were living totems that thrived on a diet of involuntary sacrifices—mostly defenseless children and the elderly. After dark, snake people would travel through the underground maze, creep into Indian camps and steal victims to feed to their hungry god-kings. In July 1876, the *Colorado Banner* captured the public's attention with an article about the vile viper gods, whose headline read:

A MONSTER OF THE DESERT
Specimens of the Saurian Species in Colorado
A Most Wonderful Snake Story

According to the article, a Las Animas rancher was searching for a missing calf one night when he spotted a huge serpent king gulping water from the Purgatory River. The sneaky serpent began to hypnotize his steed with its

seductive yellow eyes while making a strange cooing sound. The rancher was quoted in the newspaper as saying:

> *The terrible mouth, which I could see was as large as a barn door, opened, and a forked tongue darted out and pulled my beast within. Then came the sound of teeth crunching and the breaking of bones, mingled with the stifled death cry…I made the best of my way back to this place, where I arrived horseless.*

In the fascinating book *Ghosts of the Old West*, author Earl Murray tells of an account with a viper king that occurred in the summer of 1982. The story concerns an Apache known as Mahlan, who was raised with secret knowledge that he called "the Indian way." One night, Mahlan drove to his sister's Colorado mountain ranch, planning to spend the weekend. Once at her property, he got out of his vehicle to open the cattle gate. But suddenly, he noticed the musky odor of a pit viper and hurried back to the safety of his truck. The young man switched on his high beams just in time to witness two large yellow snake eyes glaring back at him from the bushes. He could also hear a strange dragging sound, like the beast was pulling something big. The thought of a serpent king lurking nearby frightened Mahlan, so he stomped on the gas and left the calamitous creature in the dust. Later, he told his sister about the unnerving incident. She didn't seem surprised, saying it must have been the same monster responsible for stalking her cattle. Both Mahlan and his sister knew about the evil snake people and their wicked viper gods. The next morning, they alerted other ranchers in the area about the wrathful creatures. However, nobody took Mahlan and his sister seriously, even though they didn't have a better explanation for their vanishing cattle. Even today, many old-timers believe the snake people and their masters are responsible for countless untold deaths of both man and beast. The lesson to this story is that you can never trust a snake, the shameful snake people or their vicious viper gods. If you ever happen to go camping in Colorado, don't forget to bring serpent repellant and, most importantly, zip those sleeping bags!

Wicked Wonders and the Chupacabra (Pueblo)

Something wicked this way comes.
—Shakespeare

Few people realize that the town of Pueblo was founded on a haunted hot spot. It all began in 1842, when El Pueblo Fort was established at the

confluence of Fountain Creek and the Arkansas River, which formed the U.S.-Mexico border. Several families lived in the fort and peacefully traded with the American Indians until fate intervened. On December 25, 1854, a party of angry natives came Christmas caroling with tomahawks in hand and slaughtered everyone in sight. Legend tells that after the ruthless massacre, the Indians refused to walk over the blood-soaked grounds out of fear of the frightful hoodoo that still lingered.

Today, a portion of the old fort has been reconstructed and is now part of the El Pueblo Museum. Local paranormal investigator Lore Buswell claims the grounds are haunted by several residual entities, including the headless ghost of an army captain. However, the veteran psychic believes the most mysterious area of her hometown is near present-day Pueblo Reservoir. Floating phosphorescent balls of light known as "witch balls" have been tormenting fishermen for decades. One explanation is that they are actually ghost orbs and that the area is haunted by all those who perished during the great flood of 1921. However, the most popular explanation tells that these mesmerizing balls of fire are actually Mexican witches known as *curanderas*, only in astral form. These mystical beings were known to have supernatural powers enabling them to become invisible and shape-shift into living animals called "familiars." Apparently, covens of *curanderas* met on full-moon nights in the wooded area near the reservoir once known as the Honor Farm. Lore confided that in the mid-1980s, she and some friends investigated the wild rumors on a dare. From a safe distance, they observed a circle of upside-down crosses and naked people chanting and dancing around an ominous-looking bonfire. When they returned the next day, the crosses were gone, but the blood-soaked hilltop was found littered with sacrificed animals, including dogs, cats, goats and a burnt cow's head. Lore and her friends immediately reported the bizarre incident to the Pueblo County Humane Society and were saddened to later learn that several of the slaughtered victims were lost pets. Lore Buswell suggests that these mutilated pets might have been sacrificial offerings to a blood-sucking demon known as *chupacabra* or "the goat sucker." Lore and fellow Pueblo native Shannon Dionese had an up-close and personal experience with the dreaded beast in August 2007. Shannon grimly recalled:

> *We were walking through the Farmer's Pavilion at the Colorado State Fair Grounds in Pueblo when we noticed a large banner with dripping blood-red letters declaring: THE VAMPIRE BEAST! A barker in a top hat stood outside the tent and exclaimed that for only a buck, guests could take a gander at a mummified chupacabra! I knew many of my neighbors had lost their pets to the bloodthirsty villains, so I was intrigued.*

After handing the barker our sweaty dollar bills, we eagerly stepped to the back of the line. It stank of cow poop, and it was so hot that farmers were feeding chickens ice cubes to prevent them from laying hard-boiled eggs! Horseflies the size of John Deere tractors buzzed overhead, apparently looking for a landing strip. After half an hour of listening to staticky music drone over the Mexican radio station, we felt like tortured prisoners of war. Just when we were about to bolt for the exit, we finally reached the entrance to the hotly anticipated shrine.

Red velvet curtains swiftly parted to reveal an elevated platform with an array of white flowers and glowing candles, which surrounded a draped box. Ethereal harp music crackled over loudspeakers. A preacher in a long white robe stepped into the canvas chamber, and the music was abruptly silenced with a wave of his hand. He began by saying that one full moon night in July 1995, fishermen found the dead chupacabra near Pueblo Reservoir and had it professionally preserved by a taxidermist. After the brief oral presentation, a trumpet blared as the drape was cast away to reveal a tiny glass coffin!

Our group was escorted to the showcase, where the butt-ugly beast was lying on its back and its bulbous head was propped upon a dainty satin pillow. To add to the drama, a little black Bible rested on its sunken chest, grasped between its razor-sharp paws. Its beastly black eyes were frozen in a demonic stare, and bloodstained fangs protruded from his puckered reptilian mouth. An Asian tourist attempted to snap a quick picture, but a guard confiscated her camera and promptly escorted her outside. Apparently, the humiliated woman didn't understand the large signs, written in English, warning that taking photographs was strictly forbidden.

When we told our colleagues at Immortal Solstice, a local dance troupe, they thought we should be whisked away to Pueblo's notorious funny farm! The following year, we treated the dancers to a day at the fair in hope of seeing the wicked wonder and proving our strange story. But much to our chagrin, the chupachabra and legendary country crooner George Jones didn't show up as the marquee had promised!

Last summer, several newspapers speculated that the chupacabra was boycotting the Colorado State Fair because of its new mandatory concession stand credit card program. However, you might be able to spot the little monster in the hills surrounding Pueblo Reservoir. Sometimes referred to as the "reservoir dogs," these hairless, supernatural creatures hatch from incubated pods planted around the lake by extraterrestrial beings. They hatch during the full moon and thrive by sucking blood from nearby

Petroglyph of the chupracabra found in Picture Canyon. *Author's photograph.*

campers. Obviously, you will want to be very careful when approaching these insidious beasts because they are considered very dangerous. However, if you do manage to get ahold of a dead chupacabra and have it carefully preserved, they make for a very impressive sideshow attraction.

GREAT BALLS OF FIRE (WRAY, ASPEN AND DENVER)

I have seen three emperors in their nakedness, and the sight was not inspiring.
—*Prince Otto von Bismarck*

Colorado has an embarrassing secret that it's been trying to keep under wraps for well over a century. However, it's time to let the proverbial cat out of the bag: our beloved state is cursed by nasty lightning.

Seasonal electric storms have always been an ominous threat to the region due to the arid climate and high altitude, which make a perfect brew

for sizzling storms. Static electricity crackling through the air has been responsible for curdling mayonnaise and souring milk. Even weirder is that sometimes lightning would assault a person without ever directly striking him or her. For example, coins and keys have melted in pockets, while metal eyelets and zippers have been blown off shoes. Once, a random lightning bolt spared a young mother but killed the babe nursing at her breast. The insidious power of lightning knows no bounds—random bolts have ripped down chimneys and squeezed through water pipes. In some cases, victims were struck but the only evidence was a small hole bored into their skin. But in other instances, people have been shockingly burned, dismembered or disemboweled by vicious attacks. During one horrific storm, a farmer lost an ear, and another had his scruffy beard shaved by the same barbarous bolt. The markings left on the body after being zapped are also peculiar. Indelible dots, stripes and zigzags burned in blue, red, green and black often remain as primitive tattoos.

One of the strangest accounts happened on June 23, 1892, when an African American sheep farmer was struck unconscious by a bolt of lightning. When he awoke, his left arm was blanched as white as snow. Another curious phenomenon is known as Saint Elmo's fire. The glowing static electricity is most often observed above the timberline when an accumulation of positive ionization meets a negative charge found hovering in low-hanging storm clouds. This electrical current can sometimes be seen when one mountain climber touches something and radiant, blue sparks fly in every direction. These same atmospheric conditions are also what cause a queer natural phenomenon locally known as "stripper syndrome." Scientists have noted that human perspiration acts like a conductor whenever lightning strikes, and it often blows clothing right off a victim's body.

One crazy story happened in 1898, near the farming community of Wray. Two teenaged girls and an elderly woman were standing by a reaping machine while chit-chatting about the latest fall fashions. Suddenly, the Grim Reaper came disguised as a kinky lightning bolt that zipped out of the clear blue sky, struck the old woman and killed her on the spot! The girls were spared but were mighty embarrassed about being struck naked as the day they were born! Sadly, Mother Nature's bawdy striptease act became a common reoccurrence in Colorado, but the queer phenomenon was much too embarrassing to ever candidly discuss out in the open. One of the first incidents to humiliate our state was when Pitkin County treasurer Robert S. Killey and Otto Hyrup were politicking to a courthouse crowd in Aspen. Ironically, Hyrup had just finished a speech about giving the shirt off his

Evidence of stripper lightning in Garden of the Gods. *Author's photograph.*

back when they were suddenly struck by lighting. Killey was unscathed, but Hyrup was left standing before the drop-jawed constituents wearing only his left sock! His shredded suit and shoes were later found 150 feet away. On August 20, 1914, the *Wray Rattler* featured an article about the embarrassing Rocky Mountain stripper syndrome with headlines that tickled its readers:

QUEER PRANKS OF LIGHTNING
Not Always of a Tragic Nature, Some Even Humorous to All but the Victims

By the late 1800s, state officials knew that something had to be done about the aggravating problem. So Colorado legislators invited noted scientists from all over the world, including Thomas Edison and Nikola Tesla, to attend an international think-tank convention. The honored scholars convened near present-day Telluride to learn how to harness the awesome power of electricity. Tesla came up with a wireless formula using alternating AC/DC current, which Edison later patented. However, the big-brained scientists never figured out how to solve the state's embarrassing stripping syndrome.

Fortunately, Coloradoans began to embrace their problem rather than trying to fix it. Ever since then, residents began looking forward to seasonal lightning storms with thrilling anticipation, especially once baseball season rolls around. For some mysterious reason, the kinky lightning bolts almost always attacks Coors Field during Colorado Rockies baseball games. This uncanny phenomenon has inadvertently become part of the titillating festivities. Once someone is struck naked, the crowd quickly follows suit, then Rockies fans happily jump up and down, doing the naked wave on the Jumbo-Tron! Family reunions are another familiar target for the insidious lightning bolts. In fact, just last summer, a dear old grandmother was struck naked at a campground. Thankfully, she later found her favorite swimsuit hanging from a nearby light pole.

MOUNTAIN MAGIC

Rocky Mountain High (Minturn)

Talk to God and listen to his casual reply:
Rocky Mountain high, Colorado.
—*John Denver*

Mountains have long been a source of spiritual inspiration. Can you imagine Moses, Abraham or Muhammad without benefit of a hilltop to preach from? Over the last century, thousands of devout pilgrims have ventured to Colorado, many believing that praying on a mountaintop brought them closer to God. One of their greatest inspirations was Mount of the Holy Cross. Legends about the towering wonder began long ago, during a French expedition of the Rockies. Apparently, a Franciscan friar accused a soldier of stealing sacramental wine. The drunkard was severely punished, but he didn't learn his lesson because he planned to steal even more "Jesus juice" with the help of a clever disguise. One night, the scorned soldier kidnapped the monk, stole his brown robe and left the tattletale shivering on a mountaintop to die. Luckily, an Indian chief witnessed the despicable episode, rescued the priest and gave him sanctuary. A few months later, the Indian clan, along with the wayward monk, stumbled upon a grisly battle scene with only a few survivors. The friar immediately recognized the drunken, thieving soldier, likely because he was still wearing his holy robe. Driven by fury, the priest grabbed a knife and stabbed the impostor in his heart! With blood on his hands, the shamed holy man left his comrades and

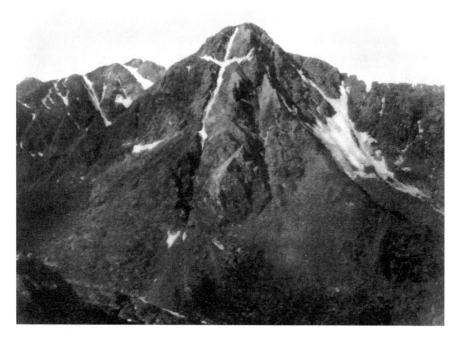

An old postcard of Mount of the Holy Cross. *Author's collection.*

wandered the wilderness for several years, hoping for a sign of forgiveness. One stormy night, the holy man prayed feverishly and then fell into a deep sleep. The next morning, the light of dawn illuminated a grand snow-white cross towering above him on the mountainside! It wasn't long before word of the exiled holy man's salvation rang throughout the country. Mount of the Holy Cross was photographed by William Jackson in 1863, and two years later, it was painted by Thomas Moran. In 1869, Samuel Bowles wrote *The Switzerland of America*, which celebrated the mountain as an American icon. Ten years later, the great poet Henry Wadsworth Longfellow wrote a celebrated poem to commemorate the anniversary of his wife's death, which reads in part:

> *There is a mountain in the distant West*
> *That, sun-defying, in its deep ravines*
> *Displays a cross of snow upon its side.*
> *Such is the cross I wear upon my breast*
> *These eighteen years, through all the changing scenes*
> *And seasons, changeless since the day she died.*

At the foot of the mountain was a crystal-clear alpine lake known as the Bowl of Tears. It was believed that the waters held curative powers because it was formed from melting snow of the holy cross. Pilgrims endeavored miles of hardships just to drink and bathe in its fabled waters. Those who couldn't make the arduous journey mailed a small donation to forest rangers, along with a personal handkerchief to be dipped in the lake and returned with a blessing. Amazing stories about healings through spiritual osmosis were often reported in newspapers, like in April 1929, when astonishing headlines for the *Eagle Valley Enterprise* praised:

AGED WOMAN GIVEN UP ON BY DOCTORS
CURED BY SIGHT OF SACRED HOLY CROSS

Sixty-Six Year Old Chicago Woman Who Insisted on Making Pilgrimage to Sacred Mountain Says Her Recovery Is a Miracle

Images of the holy mountain were reproduced on everything from calendars to postage stamps. Obviously, every marketing agency in the country wanted a piece of the pie. However, when the Philip Zang Brewing Company used the mountain's image to promote its beer, quite a few pious citizens became alarmed. Complaints about Zang's controversial advertising campaign upset people all over the country, and newspaper editors couldn't keep up with mountains of nasty letters. In June 1905, a brewing mother penned a passionate memo to the *Denver Post*, which advised:

> *The Zang Brewing Companies trade mark caught my eyes…Surely it is a sign of suffering for those who drink from the cup. I would let them use the sign as it is, only let them add streams of blood flowing from the cross…for even the drunkard with burning stomach and reeling brain, when his eyes glare upon that sign, will say, while his frame shakes: No, no, I cannot go under that sign, for I feel the blood of Jesus dripping, dripping upon me.*

However, the Zang Brewing Company never heeded the maddened mother's unsolicited advice, and Mount of the Holy Cross became a shared icon for devout teetotalers and religious drinkers alike. The holy mountain's crowning glory occurred on May 11, 1929, when U.S. president Herbert Hoover designated Mount of the Holy Cross a national monument. Banners waved, citizens cheered and the entire nation was proud of Colorado's glorious natural wonder. Sadly, around 1950, mining blasts caused a

devastating landslide, and the holy cross lost its lofty crown. Officials called the outlandish blemish "a shameful blight," and the mountain was stripped of all its honorable titles. Needless to say, tourism substantially diminished. Apparently, devout pilgrims were no longer interested in visiting the colossal capital T. Alas, all was not lost because mining and breweries became big business in Colorado. They say that inspiration is where you find it, and folks still enjoy taking trips to the high country to drink beer, pray or do both. Perhaps the late John Denver said it best when he crooned that being on a mountaintop makes you feel high!

THE ANGEL OF MOUNT SHAVANO (SALIDA)

The blood of the martyrs is the seed of the church.
—Tertullian

American Indians believed that the Rocky Mountains were the marrow of the earth and shared fables about their majestic, sacred wonders. The legends of Mount Shavano are some of the oldest tales about a holy mountain in the Colorado Rockies. One story tells that in 1853, Chief Shavano prayed for the life of his dear friend Jim Beckworth after the frontiersman was injured in a horse riding accident. Miraculously, a snow angel appeared on the mountain slope as a promise that the frontiersman wouldn't die. Sadly, Beckworth bit the dust anyway, so that story never stuck. A more popular Indian legend holds that long ago, there was a horrific drought that nearly strangled all life from the earth. Not only were vegetation and animals dying, but so too were the Ute Indians, and many wondered what they had done to anger the gods. The chief's daughter was a raven-haired, doe-eyed beauty who was well respected for her prophetic visions. The Indian princess became gravely concerned about the desperate situation and prayed for help from the Great Spirit.

One night the maiden dreamed about how she could save Mother Earth from the perilous drought. The next morning, the Indian princess chanted as she journeyed to the summit of Mount Shavano. Just as the sun peeked over the eastern horizon, she stretched out her arms like the wings of a dove and leapt to her untimely death. The gods were both pleased and saddened by the Indian maiden's selfless sacrifice: the heavens poured rain, and the earth rejoiced. That winter, a large patch of snow mysteriously appeared on the mountain slope, resembling a large snow angel. Legend tells that in the springtime, the melting

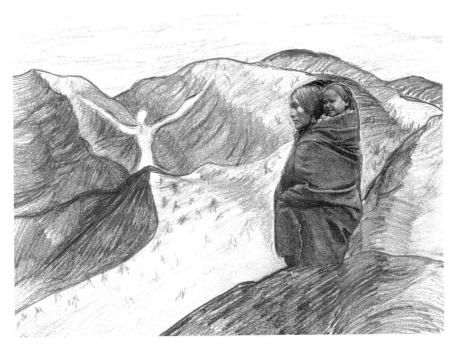

The Angel of Mount Shavano became mother of the rivers. *Author's collage.*

snow formed the angel's tears, which gave birth to the streams, rivers and lakes. Because of the Indian maiden's selfless devotion to her people, Colorado became known as the mother of all rivers. Over time, the story attracted curious, spiritually minded visitors to the mountain, as beholding the sky-high snow princess and remembering the sacred legend inspired many.

However, it didn't take long until some wise guys capitalized on the well-worn tale. In the 1920s, postcards depicting the snow angel along with a new legend were peddled to tourists. This story told of the Roman god Jupiter becoming jealous when a flirtatious goddess aroused the attention of other gods. Out of anger, the head honcho of the heavens banished the shameless hussy from his throne and forced her to live alone on the cold mountaintop every winter forevermore. As if that weren't bad enough, Jupiter forced the seductress to bear the sorrows of others. Each spring, the ethereal martyr cried rivers of tears, thus releasing her burdens in the melting snow. Storekeepers sold such novelties as the ever-popular "Angel of Mount Shavano" postcard books, saltshakers and back scratchers, making a pretty penny off the popular legend. The mountain became a gold mine, both

literally and figuratively, after a mining camp moved next door. In September 1927, the *Record Journal of Douglas County* reported that $150,000 had been raised to create the Angel of Mount Shavano Amusement Park. No doubt, investors had their eye on the prize, knowing that a seven-hundred-foot-tall snow angel would attract good paying customers. However, all hopes and dreams of the winter wonderland soon melted away like springtime snow. Yet to this very day, the angel of Mount Shavano still serves as inspiration for many as she spreads her icy wings upon the mountain in the winter and takes flight every spring.

A Hole and a Devil's Head
(Green River, Brown's Park and Sedalia)

He who is afraid of the devil does not grow rich.
—*Italian proverb*

Our state was once crawling with devious desperados and bawdy banditos. Some of their most unforgettable hideouts were located in the desolate northwestern corner of Colorado. Trappers with the Rocky Mountain Fur Company found that wild game flourished in the area. In 1837, Fort Davey Crockett was established along the Green River in an almost impregnable wilderness. However, the elusive fortress soon fell into disuse because mountain men and soldiers kept forgetting where it was located. Apparently, none of them were willing to ask for directions.

It wasn't long before wilderness-wise outlaws took advantage of the forgotten outpost. Many of these misfits were guerrilla warriors who fled to the Colorado Territory after the Civil War. The fortress became a great place to wet their whistle or roll in the hay with an Indian bride. Boisterous parties were all too common, and Fort Davey Crockett soon became known as the wickedest garrison in the west. Fugitives were attracted to the remote location because it provided a bird's-eye view of the vast surrounding wilderness. An added advantage was that the secret hideout was located near territory lines, making running for the border a snap.

Perhaps the most infamous gang to rule over the northwestern region was the notorious Wild Bunch, led by infamous outlaw Butch Cassidy. By all accounts, Butch was an affable, good-looking son of a gun, but the narcissist was always primping and patting himself on the back. Yet vanity was a flaw

N128:—DEVIL'S HEAD MOUNTAIN, COLORADO

Old postcard of Devil's Head Mountain and fire lookout. *Author's collection.*

that Butch could afford, since he was one of the richest and slickest outlaws of his time. But since the prima donna was always admiring himself in the mirror, he kept forgetting where he put things like razors, combs and bags of gold. Legend tells that after one spectacular train robbery, Butch made haste for Brown's Hole and buried his windfall in a remote cave but later forgot the secret location. As far as anyone can remember, the forgotten fortune is still buried somewhere in that neck of the woods.

Perhaps the most mysterious outlaw hangout was located in central Colorado, near the village of Sedalia. Devil's Head Mountain was named after its monstrous black rock formation, which can be seen for one hundred miles in every direction as the crow flies. They say that lightning only strikes the same place once, but Devil's Head breaks all the rules. Only God knows how many times the mountain has been zapped or the number of poor souls who have been struck dead on its peak. It's no wonder it became known as Satan's roost! Native Americans naturally feared the lightning magnet and didn't venture within its piercing gaze. The numerous caves, nooks and crannies became ideal outposts for highwaymen, and it wasn't long before Devil's Head gained a notorious reputation as a feared outlaw camp.

The most convincing stories about the hideout concerned the Collins Gang treasure. In 1871, a government wagon train was robbed, and bandits stole $60,000 in gold eagle coins. The desperados made haste for Devil's Head, but a sheriff's posse raced behind them in hot pursuit. Thinking quickly, the thieves buried the treasure near the mountain and marked the spot by plunging a dagger into a pine tree. However, the sheriff was madder than a frog on a hot skillet and was not about to let the thieving varmints escape. Once the posse caught up with the outlaws, they filled them with lead and put them to bed, so to speak. Miraculously, one bandit escaped on the wings of a prayer. The posse searched high and low, but the brazen bandit was slicker than snot and was never apprehended. The honorable sheriff assumed the deceitful desperado escaped with the treasure, and the scandal was soon forgotten.

In 1912, a fire lookout station was built on Devil's Head. Over the years, romantic legends of buried treasure enticed the occasional backpacker or armchair historian to the devil's watchtower. Mountain rangers gladly shared campfire tales about long-lost treasure and spooky ghost stories, but nobody ever took them to heart. However, jaws dropped when, on July 10, 1923, headlines in the *Colorado Springs Gazette* shouted:

AGED BANDIT SEARCHES FOR POT OF GOLD
Haunts Devil's Head Plying Strange Quest by Night in Moonlight

The article shared how veteran forest ranger Roy Dupree noticed a creepy old man who only came out of his pup tent after dark. The ranger often overheard the stranger stomping below the tower, using cuss words that would sizzle Satan. After a few weeks, he finally questioned the oddball about his moonlight madness. At first, the cigar-chomping hermit hesitated, but when hard pressed, he finally spilled the beans. The enigma claimed that he buried something valuable there long ago, but he secretly searched for it at night because he didn't want to draw unwanted attention. The grouch complained that nothing looked familiar to him, especially after fifty long years. Mr. Dupree assured the raspy-voiced oldster that it was likely because forty years earlier, a forest fire dramatically altered the landscape. The revelation seemed to further frustrate the old man, who heaved a heavy sigh, lit up another foul stogie and shuffled back to his camp. That night, Mr. Dupree could hear the old man ranting about losing his retirement fund and likely thought that the only thing the weirdo lost long ago were his marbles!

The next morning, Ranger Dupree went back to check on the senile senior but was relieved to find he was already gone. Strangely, the old man's campsite was clean as a whistle, as if he'd never been there! Dupree thought it was a bit strange but soon forgot about the wayward weirdo. Ironically, just a few days later, Mr. Dupree's buddy dropped by with an old book on lost treasure. The mountain ranger was shocked to learn the Collins Gang had buried stolen loot at Devil's Head. Authorities pursued the identity of the old cuss, but nothing ever came of the investigation. Dupree joked that being a mountain ranger had its just rewards but a high salary wasn't one of them, so he intended to hunt for the elusive treasure until the day he died.

Today, experts estimate that the Collins Gang treasure would be worth about $6 million. The watch tower is still in operation and is one of only a handful left in the country. If you plan on investigating the mysteries of the mountain, say hello to forest ranger Billy Ellis, who has manned Devil's Head for the last thirty years. Don't forget your camera, ghost hunting meter, metal detector, shovel and a lighting rod—who knows, maybe you'll get lucky!

Cursed Gifts of Grand Mesa (Grand Junction)

You can't go home again.
—Thomas Wolfe

Have you ever heard about the little old lady who was stung to death by black widow spiders nesting in her beehive hairdo? Oddly, the tall tale still persists even after half a century. But if you think the longevity of that story is impressive, then consider this ancient Indian fable that morphed into a popular urban legend. The original story is poetically relayed in the charming children's book *A Legend of Grand Mesa*, by Terri Ragsdale.

The saga began long ago, when the earth was swimming in water. A huge explosion propelled an island to arise, which became known as Thunder Mountain. On the mountaintop were dazzling lakes, rippling rivers and cascading waterfalls. Pillows of clouds gave nourishing rain that sustained tropical vegetation. In this garden of Eden, the native people were very content. However, one day, a horrific volcano scattered the Indians and consequently caused a division of the people. The natives dwelling on the east side of the mountain broke with former traditions and initiated a new spiritual utopia. Yet citizens living on the west side of the mountain kept

with traditional religious beliefs. The new religion blasted the old ways, and this angered their pious neighbors. Needless to say, it wasn't long before there was name-calling and hurt feelings. Fierce arrows and hurled rocks began flying over the proverbial fence. Sadly, just like the tragic tale of the Hatfields and McCoys, peace on the mountain was forever shattered.

The west side of the peak was ruled by a tyrannical medicine man. From his lofty throne, he bellowed that the east side of the kingdom was off limits. His edict further proclaimed that anyone caught disobeying the law of the land would be executed without exception. Adding to the drama, the holy man had a beautiful teenage daughter who, typically, never did as she was told.

One fateful day, the curious Indian princess and her handmaidens secretly ventured to the eastern side of the kingdom. Seduced by the beauty of a sparkling lake, the gleeful gals stripped down to their birthday suits and leapt into the soothing cool water. The wanton women had so much fun splashing about that they didn't notice when a thunderbird the size of a Toyota truck began circling in the skies above. The predator began scooping the lake like a buzzard searching for roadkill when it suddenly swooped down and picked up a skinny dipper to munch on. Yet just as the brazen bird was about to enjoy a delicious bite, a warrior jumped from behind a tree, threw a stone and scared the big bully away. The Indian princess was very grateful to the handsome stranger, named Tutu, so she took a precious yellow rock necklace from around her neck and bestowed it on him, saying it would bond them for life.

However, after learning that Tutu was from the wrong side of the tracks, the princess was saddened that their blossoming bond was doomed. Yet despite the inherent danger, the youths agreed to meet every afternoon for secret rendezvous. The handmaidens were sworn to secrecy; however, whenever the star-crossed lovers got together for romance, Thunder Mountain would shake with anger. One fateful day, the tyrannical ruler discovered the awful secret that his very own daughter had been betraying him. To make matters worse, the citizens demanded capital punishment! But the young lovers escaped the bloodthirsty mob and found sanctuary in a holy cave just before the summit exploded. This final assault of violent volcanic activity reduced Thunder Mountain to a mesa. To honor the sole survivors, the wind gods carved monuments out of the same yellow stone that the Indian princess gave to Tutu. They say that, to this very day, you can still see the stone lovers on what is now called Grand Mesa.

Eventually, the Indian couple left Grand Mesa to become the mother and father of the Teotihuacán nation, and their great-grandchildren lived to

Tutu and the Indian princess leaving Grand Mesa. *Author's collage.*

rule the powerful southern Aztec empire. However, before the lovers walked away, they took a small yellow rock as a souvenir. Thousands of years later, students at nearby Colorado Mesa University still practice the same ancient tradition. Whenever graduation day rolls around, you can be sure to find eager students scouting the world's largest flat-topped mountain, searching for a special rock to take home. It's claimed that the small token serves as a gentle reminder of early struggles and new beginnings in life, just as it did for the Indian couple long ago. Legend says that if graduates fail to follow the tradition, they'll never be able to leave Grand Junction, or they will keep returning for various reasons until they finally abide by the rule. However, the hopeful graduates might not realize that stealing from the mountain is illegal. But I doubt that it's a crime punishable by death. With strict rules like they had in ancient times, the party-hearty crowd at Colorado Mesa University would likely never get out of town alive.

LOST FORTUNE OF TREASURE MOUNTAIN (PAGOSA SPRINGS)

Always be careful about what you wish for.
—*Anonymous*

Want to get rich quick? Legend tells that there is approximately $50 million still buried on Treasure Mountain, making it one of the largest unclaimed prizes in world history. Occasionally, newspapers would entice readers with stories about the infamous lost treasure, like on May 15, 1921, when the *Denver Post* teased:

THE HIDDEN HOARD OF TREASURE MOUNTAIN:

Monte Cristo Legend of Archuleta County
Which Age Cannot Wither
Nor Fruitless Search Stale

Garnered Gold Buried Long Ago
By French Explorers
Who Were Killed or Run Out by the Indians

The saga began in 1791, when a Frenchman named Remy Ledoux was hired to lead an expedition to determine the mineral wealth of New France. In the San Juan Mountains, they reached the end of their rainbow, and it was there that they struck gold. The Frenchmen constructed a fort on the summit of Citadel Mountain. The region was known Spanish territory, but that didn't stop Ledoux, who pretended to be oblivious to the fact. The regiment eagerly prospected the area and mined a staggering cache of gold. In the wintertime, the Frenchmen lodged in luxury while holing up in the Spanish village of Taos. The soldiers freely spent gold illegally mined in Spanish mountains and threw money around town like it grew on trees. When locals asked why they were so far from home, the deceitful Frenchmen implied they were only taking surveys of New France. However, it didn't take long for the suspicious Spaniards to wise up to their con game. After one trip to Taos, a posse secretly followed the con artists back to their citadel. A terrific battle ensued, in which all of the Spaniards were killed along with one hundred Frenchmen.

The following winter, many of the Frenchmen died from unseasonably cold weather, and supplies quickly dwindled. Straws were drawn, and the fellow who pulled the shortest was given the dubious honor of being served—as first course. The fat friar was the first to be fried up over the flames, and they said he tasted, amazingly, like chicken. A pinch of gunpowder was used as seasoning because—even back then—the French were known for their creative culinary skills. After the snows melted, Ledoux divided the bounty and buried the surplus treasure. During the arduous journey home, the party endured many more hardships. Ironically, all but Ledoux died before reaching New Orleans. Many in the French Quarter were doubtful about Ledoux when he returned solo, beaten to a pulp and penniless. To add insult to his injuries, the governor denied association with the vagabond, calling him a miserable impostor!

However, when Ledoux died years later, his secret didn't go to the grave with him. In 1842, Ledoux's grandson planned a new expedition to claim the stash. However, little Ledoux suffered from the so-called Napoleon complex due to his small stature, and it always caused him big problems. Sadly, the expedition got off to an ominous start when little Ledoux fell off his horse because he couldn't reach the stirrups and then drowned in the Purgatory River. As if losing their inspired little leader wasn't bad enough, only a third of the soldiers made it safely to Citadel Mountain. When officials in Taos learned the greedy Frenchmen had returned for more gold, they staged a brutal attack. Only one Frenchman survived, but authorities promptly threw him in jail, accusing him of stealing Spanish gold, conspiring with the Indians and murder.

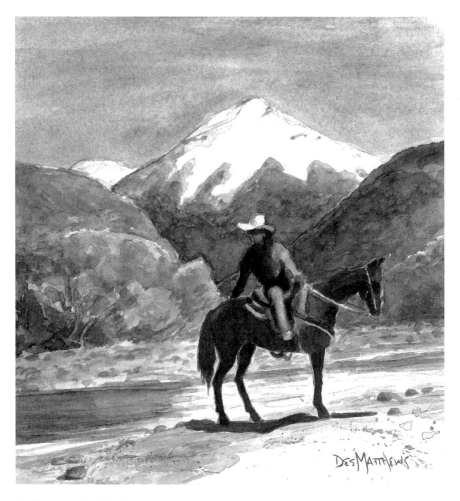

Asa Poor sought riches from Treasure Mountain. *Watercolor by Des Matthews.*

A few years later, Remy's treasure map fell into the hands of William Yull. The mountain man found landmarks indicated on the map, including rocks and tree trunks blazed with the French fleur de lis. Yull also found primitive mining tools inside a shallow shaft, but from there the hunt went cold. Eventually, the mountain man sold the treasure map to a prospector named Asa Poor. Mr. Poor wanted to be known as Mr. Rich, so he and some investors poured big bucks into the search but lost every penny they had. Legends of the long-lost treasure grew over the years until Citadel Mountain was given the more befitting name of Treasure Mountain.

Perhaps the most unlikely group seeking the riches of Treasure Mountain was a dangerous group of religious fanatics known as the Holy Rollers, headquartered in New York City. On August 23, 1913, the *Philadelphia Inquirer* published an article about the extremists as they prepared to make a pilgrimage for God and gold, with the headlines:

> *HUNT HIDDEN MILLIONS*
> *DREAM CAUSES HOLY SECT TO SEEK TREASURE*
> *Holy Rollers Start Expedition to Unearth Bullion*

Apparently, a preacher for the Holy Rollers had a vision of untold riches and boasted that God ordained him to find it in Colorado, near the town of Pagosa Springs. That summer, an army of Christian soldiers marched into the San Juan Mountains armed with Bibles, picks and shovels in search of the Holy Grail of riches, but they, too, fell short of the elusive prize. Legend tells that even today, the riches of Treasure Mountain are still waiting to be discovered. With the unclaimed prize being worth millions of dollars, it might be worth investing in a trusty metal detector.

LESSONS OF THE SPANISH PEAKS (WALSENBURG AND TRINIDAD)

He who serves God for money will serve the devil for more of the same.
—Anonymous

Tales of spacemen invaders enslaving natives and sacrificial virgins being thrown into fiery volcanoes are not lessons I remember from Colorado history class. However, legend tells that these strange incidents really happened near the Spanish Peaks eons ago. In October 1923, an article in the *Estes Park Trail* had the headline:

> *INDIAN LODGE TALES:*
> *HUAJATOLLA*

The legend of Huajatolla is also known as the saga of the Spanish Peaks. American Indians called the twin peaks Wah-ha-toy-ah, meaning "Big Breasts," which was an ample way of describing the curvaceous twin

mounds. They believed the voluptuous granite peaks were the bosom of life that nurtured all living things. Like Mount Olympus was to the Greek gods, Mount Wah-ha-toy-ah was home to a plethora of Indian deities. The head honchos of the heavens were their sun god Huajatolla and his brother, the rain god Tlacloc. It was on these twin thrones that Huajatolla cast radiant beams of light and Tlaloc made nourishing clouds. In this peaceful paradise, there was no need for making weapons or practicing war games, and harmony prevailed for many years.

Meanwhile, a mighty people arose from the mysterious southern land of the ancient Aztec empire. On high holy days, a special athletic game was held in honor of their gods. When the event ended, the champions would be honored at their holy temple. The team captain would be led to the top of a pyramid, where he would lie on a stone altar. After the hoi polloi was silenced, the high priest would recite mysterious incantations and then plunge a fierce obsidian dagger into the athlete's chest, rip out his warm heart and devour it while it was still beating. These temples were frightening places with imposing images of monstrous deities, like winged serpents and scorpions, painted on the bloodstained walls. Forged from solid gold were vulgar statues of jaguars and exotic birds with human heads. Lavished upon these freakish idols were priceless gifts of rare gemstones. As this wicked empire flourished, they ventured beyond their lands in search of more treasure to feed their hungry gods

One fateful day, these warriors arrived in the peaceful valley of the Spanish Peaks riding in a "winged rock ship." At first, the invaders were kind toward the natives by teaching them better ways to hunt, fish and plant crops. However, once the intruders discovered gold in the mountains, they lost all interest in philanthropy. The tourists immediately enslaved the natives to mine the peaks, and a bustling mining camp was established. Tons of gold was stolen in order to decorate elaborate Mexican shrines of Huitsilopochtli, Tlacopan and Tezca. But mining eventually angered the gods, and they cursed those seeking Huajatolla's gold. The peaks erupted in anger, spitting molten lava into the heavens and smothering the beautiful green valley in black soot. Rain ceased falling from the heavens, waters evaporated, animals perished and crops withered on the vine. A couple sacrificial goats were tossed into the volcanoes, but to no avail. Finally, in an act of maddened desperation, the Indian chief threw a dozen screaming maidens into the flames! (This awful solution was obviously a man's idea.) After the freaky femme fry, the astonished tourists climbed into their "winged rock ship" and flew back into the heavens. The great sun and rain gods found forgiveness, and peace was restored in paradise.

Gold mined from the Spanish Peaks was used to decorate Mexican temples. *Author's photograph.*

After the troublesome experience, you'd think the natives would have learned a valuable lesson about not trusting strangers, but it wasn't so. When the Spaniards came along in the sixteenth century, the hospitable natives welcomed them like spring rain. The army was led by a monk named Fray de la Cruz, who announced he was on a holy mission from God and needed gold to build a new church. The humble Indians acknowledged the secret treasure but warned them not to go near the accursed mountains. However, the Spaniards wasted no time enslaving the locals. Once their wagons were filled with gold, the greedy thieves escaped with the immense fortune. In 1811, an early-day pioneer with the surname of Baca found a few gold bars scattered about a trail below the twin peaks, as well as an open fissure of escaping steam. Baca had heard stories of a greedy treasure-hunting monk being swallowed by an angry volcano and reasoned that there might be some truth to the legend. Adding to the mystery, in 1861, a prospector was panning for gold near the Spanish Peaks when he found an antique silver cup that was engraved with the name "Hermione." The goblet was believed to be a lost relic from the Spanish expedition—either that, or it was accidently left there by Harry Potter.

Even to this day, the lost treasure of the Spanish Peaks is still waiting to be discovered by someone not intimidated by ancient evil spirits or the powerful Indian curse. Did extraterrestrials teach ancient civilizations how to build pyramids or show the natives how to better hunt for game and plant crops? No one can argue that there is still much to be learned about this ancient tale. If you

want to investigate the mysterious legend for yourself, then head to the Spanish Peaks, located between the towns of Walsenburg and Trinidad. The locals there are very friendly toward tourists—just don't ask them to help you dig for gold!

PIKES PEAK: RATS, CATS AND SNOW SNAKES (COLORADO SPRINGS AND MANITOU)

There is only one step from the sublime to the ridiculous.
—Napoleon Bonaparte

There is danger lurking in the Colorado Rockies, and I'm not just talking about hazardous driving conditions, narrow mountain passes, twisting roads or your kid barfing in the back car seat. We're talking about a seemingly wholesome tourist attraction commonly referred to as "America's Mountain." Pikes Peak has enjoyed an honorable reputation ever since Katherine Lee Bates wrote the inspirational anthem "America the Beautiful" while gazing from the summit. Over the years, the song's popularity enticed millions to visit Colorado. The mountain's gift shops sell T-shirts, coffee mugs and snow globes, all bearing its lofty, snow-capped image. No doubt, peddling souvenirs is big business. Naturally, tourism officials endeavor to keep the mountain's unsung mysteries a tight-lipped secret, especially concerning the snow snake. In Latin, these elusive critters are called *Serpentus temperamentalus*, but they are also known as albino snakes. These pink-eyed serpents make wonderful pets, but they typically get mean with age. In the olden days, it was not uncommon to hear stories about seemingly tamed snow snakes being raised as family pets, turning outlaw and devouring cats, dogs and even small children!

One story tells of a pioneer known only as "Old Swede" who rescued an injured baby albino snake and touchingly raised it as his only child. Tragically, Old Swede was eaten by the ungrateful reptile once it became a teenager. The *Colorado Springs Gazette* reported that a man from St. Louis captured a snow snake on the summit of Pikes Peak and made a killing by charging other tourists a nickel each just to pet the elusive serpent. Curiously, nobody ever questioned the reptile's uncanny ability to thrive in the snow. But selling albino snakes eventually became illegal because they were feared to be dangerous. Once the vipers were outlawed, a bounty was placed on their heads, and hunting them became a popular sport. Eager trophy collectors were always willing to pay big bucks to see snow snakes dead or alive. However, overhunting the creature is likely

Pikes Peak behind Garden of the Gods. *Author's photograph.*

the reason that you hardly ever see them anymore. Yes, snow snakes are still around, but they have learned to be stealthy. Now they only travel in pairs, slithering side by side—parallel style. Obviously, they traverse this way in order to watch one another's backs. You might have noticed their trails but probably didn't recognize them as such. Their long, skinny tracks appear in fresh, powdery snow and are always found surrounding ski resorts.

One of the most maddened monsters to ever inhabit Pikes Peak was the fearful mountain rat. The carnivores' hardy digestive systems were capable of processing anything from soup to nuts, but the raunchy rodents' preferred diet was young, succulent human meat. Legend tells that many innocent children were eaten alive by the mountain rats, including a baby girl named Erin O'Keefe. In fact, the frightening news and funeral photographs made international headlines. Weeks later, the story was discovered to be only a silly joke. However, the tasteless prank did nothing to quell fear of the roguish rats, and alarmed citizens demanded justice. On January 17, 1892, the *Philadelphia Inquirer* ran this front-page headline:

A SCHOONER OF CATS
How a Pioneer Made a Fortune off a Queer Cargo

The article explained that a swift-thinking Dutchman decided to help his fellow countrymen in Colorado with their very serious problem with voracious mountain rats. Apparently, his Pennsylvanian village was overrun with feral cats. The Dutchman put two and two together and came up with a practical plan. He loaded the wild cats into his wagon but quickly ran out of room, so he built a three-story extension on top of the prairie schooner. Windows were cut into the sides for his passengers' viewing pleasure, and his wife made dainty lace curtains. But alas, after all that hard work, the towering "cat house" was too heavy to roll. However, the Dutchman was a clever sort, who figured there was more than one way to skin a cat, so to speak. He tied a pink bed sheet to the roof as a makeshift sail, allowing the wagon to take full advantage of eastern winds.

Like the Pilgrims setting sail for the new world, the Dutchman and his wife finally ventured across the wide-open prairies toward Pikes Peak in a rolling sailboat of hissing wild cats. Miraculously, only three dozen kitties perished along the way, but it made little difference, as the couple had plenty more to spare. Besides, the dead refugees made for hearty meals during the trip. The Dutchman's thrifty wife used the delicate bones of the dead critters to make intriguing necklaces, bracelets and earrings, which she sold along the way for mad money. As expected, the screaming, hungry felines propelled the party to Colorado in no time at all. Once the couple spied the Rockies, they tore the sign off their schooner proudly declaring "Pikes Peak or Bust!" and replaced it with one shouting "Ravenous Mad Cats for Sale—Cheap!" At the base of Pikes Peak, they sold all their precious cargo and the entire line of exotic feline bone jewelry! Needless to say, the hungry cats weren't afraid of Colorado's fat rats, which were already getting too plump to put up a good fight anyway.

A colossal apelike monster known as Bigfoot also roams the mountain and has been spied by many reliable witnesses over the years. Concern over safety issues inspired local activists to campaign for a Bigfoot crossing. The sign is located at the first rest stop going up the Pikes Peak Highway. You can't miss it because it's located right next to the large billboard warning about Pikes Peak snow snakes, mountain rats and Pennsylvanian pussies!

4

HAUNTED HILL AND DALE

The Phantom Fiddler (Silver Plume)

*Footfalls echo in the memory
Down the passage we did not take,
Towards the door we never opened,
Into the rose garden.*
—*T.S. Eliot*

It might be hard to believe, but there is a Colorado town that's been tortured by one insidious spirit for over a century. The rumors began during the metal boom of the late 1800s. The mines in the canyon surrounding this hamlet were producing and paying well; however, after a mysterious tragedy unfolded, the mining camp became haunted. The residents eventually abandoned their homes, which literally and figuratively turned the village into a ghost town. They say the sleepy mountain hamlet is still haunted by the sadistic ghost—perhaps that is why only a handful of brave residents live there today. The town was given its romantic name long ago by newspaperman and hotelier Luis De Puy, of neighboring Georgetown, who was quoted in the newspaper as exclaiming:

*Knights today are miners bold,
Who delve in deep mines gloom,
To honor men who dig for gold,
For ladies who their arms enfold,
We'll name the town Silver Plume!*

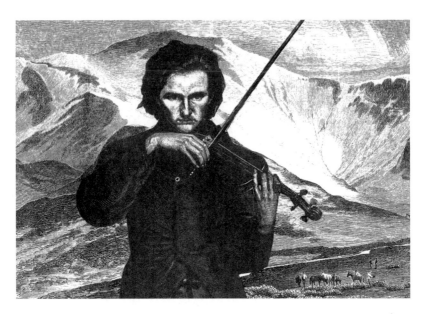

The phantom fiddler still haunts Silver Plume. *Author's collage.*

No doubt, the most mysterious so-called knight of Silver Plume was an eccentric bachelor by the name of Clifford Griffin. Born in England with a silver spoon in his mouth, Clifford had traveled the world before following his dream to Colorado. In Silver Plume, his older brother Heneage hired him to manage his struggling silver mine. They named their enterprise the "7:30 Mine" because it opened an hour later than others. The welcomed schedule change was all part of a grand master plan to make the miners happy, which soon made the 7:30 Mine the most successful company in the district. The generous brothers rewarded their loyal employees by paying them far above standard wages. Although Clifford could have afforded a castle, he built a simple cabin near the 7:30 Mine. The few who visited the recluse claimed his remote cliffside cabin was finely furnished with imported rugs, rich velvet draperies and bookshelves overflowing with leather-bound classics.

With his boyish good looks, the wealthy bachelor could have had his choice in pretty gals but instead preferred solitude. Sadly, his best friends in the world came to be his trusty fiddle and his ever-present flask of hooch. Rumors swirled that the bashful bachelor's sad eyes betrayed a deep dark secret. Apparently, crossing an ocean did nothing to make him forget the haunting memory of a long-lost love. The tragedy happened when his fiancée left him standing at the altar. Mystified by her cruel rejection, Clifford rushed to her

hotel room—only to find her lying in their bridal chamber, deader than a doornail. Investigators concluded the belated bride had been strangled to death the evening before. Unfortunately, a motive was never found, and the book was soon closed on the hopeless investigation. Was it possible that the mysterious bachelor had something to do with his fiancée's murder? Clifford never spoke of the awful tragedy, but he clearly channeled his sadness into the music he played. Near his cabin was an immense flat rock, which protruded over Silver Plume and became Clifford's makeshift pulpit.

Upon this lofty stage, Mr. Clifford Griffin showed thanks to his many employees by performing nightly concerts with his magical violin. Every night at sunset, the miners would sit outside their cabins smoking pipe tobacco and listen for the first musical note to echo through the canyon. It was a call for them to gather their families, as the thrilling performance was about to begin. Once Clifford stepped onto the stone precipice, the townsfolk would erupt into thunderous applause until he swiftly silenced them with a wave of his top hat. As the virtuoso slowly pulled the bow across the strings, ethereal music spilled over the canyon below and into the heavens above. The soothing lullaby didn't stop until the Sandman came knocking and a canopy of stars filled the sky.

As the years passed, Clifford slowly became a mere shadow of the great man he once was, and his formerly inspiring concerts took on a sinister undertone. The townies began resenting the melancholy marathons because they never got any rest. But to whom could they complain, since the mad musician was their generous boss? Furthermore, they collectively felt like they'd sold their soul to the devil. The evening of June 10, 1887, was rumored to be the tenth anniversary of Clifford's ill-fated wedding day. His reluctant audience thought they might be spared from the ghoulish performance when a violent lightning storm raged through the canyon, but sadly, they were terribly wrong. After the storm cleared, the determined maestro stepped onto the soggy stage and tortured his hostages with yet another remorseful rhapsody. As the sky darkened, the full moon silhouetted the morose musician with his head bent over his instrument of destruction, fire flew from his fiddle and it looked as though the madman was channeling the devil himself! The feverish music bounced off the canyon walls, shattering windows and pounding ear drums. For hours, the fiddler danced wickedly above the hamlet like a cat on a hot tin roof. The screeching raged on until his brow was drenched in sweat and his boney fingers dripped with blood. It was by far the most grueling performance the victims of Silver Plume had ever endured. Then, mysteriously, at the stroke of midnight the theater of pain was abruptly silenced—by the deafening sound of a single gunshot!

With lanterns in hand, a group of concerned miners charged up the mountainside to check on the demented Englishman. After knocking on the cabin door, they waited for what seemed like an eternity of spine-tingling silence. Into the looming darkness, they called out Mr. Griffin's name but were answered only by the hoot of a sleepy-eyed owl. Suddenly, a piercing scream shattered the stillness. Come to find out, one of the men fell into an unseen hole. But the lucky louse wasn't hurt because he landed on something soft: his boss! Inside the crude grave lay the mad fiddler of Silver Plume, deader than his beaver top hat. At his side was his trusty violin and an empty bottle of tonsil varnish. A suicide note instructed that his body be left in the grave of his own making. Oddly, the weapon was never found. The sheriff reasoned that the mad man shot himself in the heart and then threw the gun over the cliff before falling into the crude grave. Heneage accepted the unfathomable explanation and honored his brother's dying request. Sadly, the touching honor did nothing to appease his brother's angry spirit. For the very next sunset, the unexpected yet familiar haunting melody of the menacing fiddler pierced all tranquility! This haunting performance happened night after night until, finally, the frightened villagers begged that something be done. Yet an exorcist wasn't available, so all they could do was pray for a miracle. Then, one day, Heneage erected a colossal ten-foot-tall monument, carved from black Gunnison granite, to stand like a loyal sentinel over the lonesome grave. The monument reads:

> *CLIFFORD GRIFFIN*
> *Son of Alfred Griffin ESQ. of*
> *Brand Hall, Shropshire, England*
> *Born July 2, 1847*
> *Died June 19, 1887*
> *And in Consideration of His Own Request*
> *Buried Near This Spot.*

Sadly, the costly marker did nothing to placate the seemingly restless spirit of Clifford Griffin. Over the years, newspapers would recall the tragic ghost story. On August 16, 1959, the *Colorado Springs Gazette* said:

> *ENGLISHMAN'S GHOSTLY MUSIC*
> *RECALLED IN SILVER PLUME*

Even to this day, the ghost of the mad fiddler can still be heard playing from cliff tops at sundown. The haunting melodies still reverberate through the canyon just as they did long ago. Even more unsettling is that the mournful ghost

of the Englishman is still seen on his lofty stage, silhouetted against moonlit skies. They say the tall, slender apparition appears in a dark suit and beaver top hat playing his violin near his massive tombstone. Many theories abound about why the maddened Englishman still haunts his grave and the town below, but there is no doubt that he still does, even after 135 years. The clifftop grave of the phantom fiddler even received a nod in *Ripley's Believe It or Not!* For a map to the haunted hot spot, please visit Silver Plume's George Rowe Museum, open from Memorial Day through Labor Day.

TALES FROM THE CRYPT (CRIPPLE CREEK)

It's no wonder that truth is stranger than fiction: fiction has to make sense.
—Mark Twain

Back in the olden days, superstitious folks had some mighty peculiar customs regarding the banishment of spirits. If someone wanted to avoid a ghost, he'd turn his clothing inside out and backward so that the paranormal intruder couldn't enter his body. Charms containing mustard seeds and garlic pods were also worn to keep ghostly specters at bay. Today, ghost hunters are more interested in attracting spirits rather than trying to repel them. In fact, one of our state's most popular paranormal hot spots is the old mining town of Cripple Creek, located in the haunted heart of Colorado.

The mining hub got its start in 1874, when Crazy Bob Womack struck gold in a cow pasture known as Poverty Gulch, which ignited the "Pikes Peak or Bust!" gold rush. It wasn't long before the once-peaceful farming community of Cripple Creek became better known as Dante's inferno! On September 17, 1895, headlines for the *Aspen Daily Times* screamed:

VERY WICKED TOWN
How Cripple Creek Is Pictured in the East.
The Lurid Word Painting Which a Writer Uses to Excite
The Imaginations of Tenderfeet in New York

Furthermore, the *New York World* christened Cripple Creek "the Wickedest Town on the Continent," and it's no wonder: the burgeoning camp was crawling with ruthless desperados, and violence was an everyday occurrence. Life was cheap, but several prolific undertakers made a killing off the dead. A large red brick building was established on the corner of Bennett and Third Streets,

known as the Lampman and Black Funeral Parlor. Unfortunately, shortly after the mortuary was erected, it gained a dreadfully haunted reputation. On October 15, 1898, headlines for the *Cripple Creek Morning Times* screamed:

CAME BACK TO LIFE
AN AWFUL LOSS OF LIFE
Surgeon's Nerve Racking Experience
Sat Up in His Coffin
Man Terribly Mangled Comes to Life
And Frightens the Undertaker's Man Almost to Death
Mass of Flesh and Bones Tries to Speak.

The physician's assistant was quoted in the newspaper as saying:

If I live to be a thousand years, I would never again expect to see such an awful sight. There sat that THING actually sitting up in the coffin with bloody eyelashes, face, grinning teeth and hanging jaw, ogling and moving uncertainly about…It had worked with the stumps of its arms until the coffin lid had given away and fallen off. The noise had brought the attendant who had been sleeping in the office and he simply collapsed at the sight. I walked over to where the THING was swaying about in the coffin and it actually tried to speak but its broken jaw, torn tongue and throat made it unintelligible. It lived until early morning and then died.

Shortly after the tragedy, the "THING" was often seen lurking about the building and frightening off good paying customers. Needles to say, running a haunted mortuary was bad for business. Funeral directors sprinkled the hallways with holy water, hung a crucifix in every room and turned their clothing backward and inside out, but nothing seemed to appease the formidable foe.

Unfortunately, the mangled miner wasn't the only ghost to haunt the old funeral homestead. According to locals, Maggie has always been the most popular ghost at Lampman and Black. Her spirit is believed to be that of a shady lady who was shacking up with a distinguished politician at the National Hotel when the Grim Reaper came knocking. The man's wife arrived at room 307, under the guise of delivering a telegram, and shot the unwitting harlot in the heart with a Colt revolver. Maggie got the message. The love triangle and subsequent murder case was a huge sensation, and everyone from ranch hands to schoolmarms delighted in gossiping about the hot topic. Tongues wagged even more when nobody offered to pay Maggie's

Maggie was put on ice until she could be buried. *Author's collage.*

burial expenses. The sultry seductress had plenty of curious visitors, though. Every day, townies paraded by the funeral parlor window just to gawk at the shameless hussie lying naked on a bed of ice. Lampman and Black became a veritable circus when folks began collecting macabre souvenirs by rubbing hankies into Maggie's clotted blood and snipping locks from her beautiful long hair. Finally, the tortured corpse was wrapped in a funeral shroud and dumped in a pauper's field. To add insult to Maggie's injuries, the scorned wife was never prosecuted, and the couple rekindled their rocky marriage.

After the way Maggie was mistreated, it's no wonder she began haunting the funeral parlor. Shortly after Maggie's dismal disposal, her ghost was seen at Lampman and Black shopping for proper coffins until the mortuary finally closed its doors decades later. The old funeral parlor was eventually transformed into apartments, then the Sarsaparilla Ice Cream Parlor and, finally, the Colorado Grand Hotel and Casino. However, despite all the inevitable change, one factor remains the same: the building is still haunted. The old underground morgue has since been turned into Maggie's, a restaurant named after its infamous ghostly guest. On September 28, 2013, website designer Ranee Langlois was staying at the haunted hotel while attending the annual Spirits of Colorado paranormal convention. She was enjoying a cup of coffee at Maggie's when a

pale young woman with matted hair walked by her table and into the bathroom. She said she couldn't help but notice the peculiar stranger because she was wrapped in a wet bed sheet. After about ten minutes, Ranee decided to check on the enigma, joking that she wanted to make sure she hadn't "died in there!" After knocking on the door, Ranee was answered by only spine-tingling silence before she noticed that the light was turned off. Suddenly, Ranee realized that she'd just seen the mysterious ghost of Maggie!

Still another haunted crypt in Cripple Creek can be found in a hotel. Surprisingly, the elegant Hotel Saint Nicholas was originally built as a Catholic hospital. The subterranean crypt was necessary to keep corpses frigid until they could be properly buried. Now the morgue is a charming pub where they serve spirits of every kind—including the ghost of an old miner. Paranormal investigator and professional psychic Dori Spence believes that there are several phantoms that call the old hospital home. Ms. Spence claims that the ghost of a miner often makes his appearances at the pub during happy hour and appears so lifelike that many have thought him to be a customer. The misty miner made a lasting impression on current owner Susan Adelbush. In 1995, Susan bought the abandoned haunted hospital, but she wasn't spooked by rumors because she simply didn't believe in ghosts. One afternoon, Susan was startled when the specter suddenly appeared and sat down next to her like they were old pals. The paranormal stranger smiled at her with a seductive grin and then mysteriously disappeared right before her eyes. She joked that customers seeing pink elephants in the old morgue tavern was one thing, but flirty phantoms making the move on her was quite another! Needless to say, the strange experience made a true believer out of the former skeptic. Over the last twenty years, the fine hotel has attracted the attention of ghost hunters from all over the country. So, if you're the sort who enjoys haunted tales from the crypt, then head to Cripple Creek and have a stiff drink on the dead!

CITIES OF THE DEAD (DENVER, COLORADO SPRINGS AND LEADVILLE)

Life is a city with strange streets and death is the marketplace in which we'll all meet.
—William Shakespeare

The year 1976 was certainly memorable. It was the 200th birthday of our nation, as well as Colorado's centennial. It was also the year that I fell into

my great-grandmothers grave. I went to the rural cemetery near the town of Cheraw, hoping to get a photograph of her headstone for my genealogy records. Just as I snapped the picture, the earth caved in. I fell three feet before my cousin pulled me out by my bra strap and saved me from a gruesome fate. To add to my horror, hundreds of black beetles crawled out from the crumbling abyss. My cousin teased that I looked like I'd seen a ghost!

If you want to be spooked, then visit one of Colorado's many haunted pioneer graveyards. Glowing ghost lights, also known as corpse candles, have been seen in the Silver Cliff Cemetery since the late 1800s. Over fifty people witnessed the strange phenomena in April 1956, and the astonishing news made national headlines. *Life* did a full story on the mystery back in 1969 but never concluded what caused the weird mystery, which can still be witnessed today.

Denver's Chessman Park was once the city cemetery, until it was renovated in 1890. Most of the graves were relocated; however, an unscrupulous cemetery director pocketed removal fees and plundered many of the burial sites. His illicit activity might have gone unnoticed if it weren't for the ghost of an Irish lassie who foiled his greedy plans. Workers opened her coffin, hoping to identify its remains for relocation, when the unmistakable fragrance of rose blossoms inexplicably flooded the air. Stranger still was that although the young woman had been dead quite a while, the corpse showed no signs of decay and actually radiated an ethereal beauty. The Irish maiden's auburn hair was set with tiny white flowers, and she looked just like a sleeping angel. Superstitious crewmen were overcome with emotion and understandably walked off the job. When word got out that a possible saint was in their midst, the Catholic registry stepped in to perform an investigation. However, nothing could be determined about the pretty-smelling corpse, and plans to have the beauty beatified were promptly dismissed. After the mystery hit newsstands, attention was drawn to the unscrupulous activity going on during renovations. The thieving cemetery director was promptly arrested, and justice prevailed.

However, the intervention did nothing to quell rumors about Chessman Park being located on haunted grounds. Supposedly, there are about two thousand coffins still buried beneath the lawn, and locals joke that the natural fertilizer helps keep the grass green. Many believe the park is teeming with angry spirits, including former Denver resident Christopher Allen Brewer. As a teenager, Chris often took advantage of Chessman Park, using the natural tanning beds formed in the lush, green grass. It wasn't until several years later that he learned he'd been sunbathing on sunken graves. In 2012, Christopher and his paranormal investigation partner James Manda, known as the Spiritchasers team, filmed a segment with the Biography Channel

about the haunted park for their popular program *My Ghost Story*, which can still be seen on YouTube.

Not to be outdone, Colorado Springs's Evergreen Cemetery has also been featured on *My Ghost Story*. The city cemetery is listed on the National Register of Historic Places and has long been known to be haunted, but on June 24, 1904, it became official. On that fateful day, Delos Powell, the cemetery director, was confronted by the police about funds missing from community coffers. After he was released on bail, Powell drove to the graveyard with murder in his heart. Once there, he scribbled a quick suicide note and then drank a bottle of gopher poison. But the deadly remedy failed to work its magic quick enough, so he shot himself in the head. Powell was rushed to the hospital in a hearse but died on the operating table. Doctors wryly noted that the undertaker's suicide was just a bit "overkill."

Ever since the tragedy, the ghost of the former cemetery sexton has been spotted in the basement morgue of the chapel, still sporting his trademark wide-brimmed hat. In 2010, cemetery volunteer Mike Coletta caught a ghost on video and posted the astonishing evidence on YouTube. It wasn't long before Hollywood came calling. Mr. Coletta and current cemetery director William De Boer filmed a segment about the haunted morgue for the Biography Channel. Since then, several paranormal investigation groups have verified that the chapel is haunted by legions of spirits. The All-Girl Paranormal Society investigated the grounds and recorded some amazing EVPs (electronic voice phenomena) of people talking and children laughing in the morgue. But professional psychic Laura Westfall believes that the most prevalent spirit in the in the chapel belongs to Mr. Delos Powell. Perhaps he still haunts his old "digs" because he was buried in the cemetery of his undoing and shamefully lies in an unmarked grave.

Still another haunted cemetery sharing the name of Evergreen is located in Leadville. Author Roger Pretti is an expert on the haunted history of Leadville and gives tours from the historic Delaware Hotel. I was lucky enough to go on his tour of Evergreen Cemetery, which was much more informative than when I previously explored the decrepit boneyard on my own. This spooky cemetery is located in a thick forest of lodge pole pines, and many graves are so old that tree roots have wrapped around coffins and lifted them to the surface. Needless to say, finding ancient caskets peeking out from the pitted underworld is not uncommon.

One of Evergreen's most infamous ghosts was once a womanizer by the name of Edward Frosham. On November 20, 1879, Eddie was lynched for jumping mining claims and married women—not just once, but twice. Apparently, "Ready Eddie" wasn't ready to meet his maker and thought he

could skip home scot-free after the hemp necklace snapped, but it wasn't his lucky day after all. The thieving adulterer was strung up again, but it took over twenty minutes for the scoundrel to finally strangle on the strengthened noose. So it seems reasonable that his angry ghost would hang around the cemetery. Evergreen is also where Joseph Prince was buried—sort of. Joseph was tragically blown to smithereens during a mining accident. All that was found of the handsome bachelor was a single body part. His nose was given a decent Christian burial and its very own tombstone. Leadville's Evergreen Cemetery is also the burial place of James Driver's arm and the foot of Mrs. E.J. Burdett. However, ghost hunters don't believe these severed appendages are responsible for any haunts. Even so, Leadville's creepy Evergreen Cemetery is likely the spookiest place you'll ever *die* to visit.

FOREVERMORE TRICKSTERS (CENTRAL CITY)

Heaven has no rage like love to hatred turned, nor hell a fury like a woman scorned.
—*William Congreve*

Many ghost story aficionados might be familiar with the infamous legend of the so-called Poe Toaster. After celebrated author Edgar Allan Poe passed away, a mysterious mourner visited his grave annually on the anniversary of his death. At sunrise, a veiled woman in black leaves three dead roses on Poe's grave and then toasts to his memory with a glass of cognac before disappearing into the mist. The master of the macabre died long ago, yet this tradition is still carried on today. However, no one knows who the ghostly mourner is, or how it's possible that she's carried on this tradition for over a century. Colorado is home to a similar legend of an eternally faithful mourner.

The ghost story begins with a handsome young man named John Edward Cameron. The bashful bachelor worked as a fireman with the Central City Rescue, Fire and Hose Company. John was a chivalrous sort of fellow, who rescued panicked kittens out of treetops and helped little old ladies cross the street. The happy-go-lucky heartthrob was also popular with younger women but never dated anyone in town. However, nearly every afternoon, Johnny Boy would pick a bouquet of blue columbines before hiking over to Bald Mountain. Gossip in the ladies' sewing circles told that the mama's boy had a mysterious lover living near the moutain. The cackling hens claimed that his ladylove was actually a conniving witch who seduced him with powerful black

magic. However, speculation about the sorceress didn't stop the gabby gals from constantly making goo-goo eyes at the dandy dude. If only they knew that these innocent flirtations could have been what led to Johnny Boy's untimely death!

In late September 1887, John returned home from one of his usual afternoon walks, saying he felt suddenly ill. His mother made him a bowl of chicken noodle soup and tucked him into bed, yet the next morning, her only child's condition had worsened. The fireman's many strange symptoms were unlike any the doctor had ever seen, and there wasn't much he could do without knowing the source of John's ailment. John's mother and friends quizzed him about what happened before he was stricken, but he just blankly stared into space with a faraway look in his eyes. Exactly one month later, on November 1, John's doting mother went to check on him and was horrified to find her Johnny-boy dead. Apparently, he'd died on Halloween night with his eyes wide open and a look of unimaginable terror mysteriously frozen on his face. Sadly, he was only twenty-eight years old.

On a cold, dreary morning, six black stallions slowly pulled the glass-paneled hearse uphill to the Masonic Cemetery. The Gilpin County Reed and Brass Band, along with an army of sobbing mourners, followed the sad funeral entourage. Everyone knew one another, with the exception of a suspicious veiled woman in black. When the gravesite service concluded, the mysterious mourner set a bouquet of blue columbines on the bachelor's grave and then headed on foot toward Bald Mountain. Townies wondered who the beautiful woman was and where she found living columbines in the dead of winter. It wasn't long before locals speculated the raven-haired vixen was a sorceress who poisoned John out of jealousy. Needless to say, everyone hungered for answers as to why John suddenly died in the prime of his life of what was called a broken heart.

Strangely, the mystery didn't stop there because on April 5, 1888, the witchy woman appeared at his grave once more, and then again on the first anniversary of John's death. Each time, the enigma only lingered for a brief moment before leaving a bundle of blue columbines near the white marble headstone. Even to this day, the steadfast woman in black still haunts John's grave with a bundle of blue columbines every April 5—and during the witching hour on Halloween night. In fact, just a few years ago, a group of ghost hunters waited for the phantom to appear on Halloween night and chased her into the woods until she disappeared into the ether. No one seems to know why the mysterious mourner comes to visit on April 5, or how it is possible that she faithfully makes these semiannual visits even after 130 years.

A veiled woman haunts John Cameron's grave. *Illustration by Vanessa Dolbow.*

LeeAnna Jonas is the owner of SRIP Paranormal Investigations and knows all about the ghosts of Central City. One of her favorite tales is about the Teller House Trickster. The Teller House was built as a fine hotel in 1872. Its tavern sold the finest spirits in town but later became known for spirits of another kind. The walls of the pub were painted with classically themed Greek murals, which can still be seen on tours. However, upon close inspection, it becomes apparent that the artist had an oddball sense of humor. One of the life-sized goddesses has broken fingers, and another is missing toes. Adonis has his head on backward, and Venus is depicted holding a detached nipple from her left breast. However, the strangest mystery concerns a face on the barroom floor. Likely, many a cowboy had their mug planted on that old saloon floor, but this face belongs to a beautiful woman. In the late 1800s, both John Henry Titus and Antoine d'Arcy took credit for a famous poem called "Face on the Barroom Floor." The tear-jerker was about a drunk who painted his lover's portrait on the floor and then died next to it in a pool of tears. For many years, the person who painted the mysterious face at the Teller House remained unknown. That's because the artist snuck into the pub during the middle of the night to compose the curiosity by candlelight. Many years later, an artist named Herndon Davis confessed to the practical joke on his deathbed, claiming it was a picture of his late spouse. Incidentally, Herndon's high-

One of several baffling paintings at the Teller House. *Author's photograph.*

society wife just happened to be a teetotaling reformist who would have been mortified knowing her face was plastered on the floor of a popular tavern. Could it be the ghost of Herndon's wife that still lingers at the Teller House? Maybe the sulky suffragette haunts the bar because she's trying to save face! Paranormal investigators have confirmed the Teller House is haunted. They say that hell hath no fury like a woman scorned, and in Central City, this well-worn adage seems to be true!

HAUNTED HOLY HOLES
(SPRINGFIELD AND SWEETWATER LAKE)

The communication of the dead is tongued with fire beyond the language of the living.
—T.S. Eliot

In ancient Greece, at the temple of Delphi, priestesses went into a sacred cave that emitted sulfuric fumes and induced a psychic trance, enabling them to act as oracles to their people. Hermitic philosophers like Lao-tzu and John of Patmos also used caves as holy sanctuaries. Colorado is home to many

caves, and we know that some of them were held sacred to ancient peoples. There's Crack Cave, located in Picture Canyon, which has long been known for its ancient rock art. However, it wasn't until 1976 that the significance of the holy cave hidden in the canyon was discovered.

The explorers were amazed to identify ancient Celtic text known as Ogham carved on the sandstone walls. Ireland has the most riveting examples of the ancient text, leading historians to consider the possibility of Celtic people crossing the Atlantic long before Columbus or even the Vikings. Adding to the ancient mystery is that during the Celtic holy days of spring and fall equinox, the first light of dawn creeps through the narrow cave entrance and briefly illuminates the Ogham text etched into the sandstone wall. Noted scholars have interpreted the ancient writing as saying, "The sun strikes [here] on the day of Bel." The word "Bel" is believed to be a shortened version of "Belenus," the Celtic sun god. The armchair archaeologists who discovered the ancient holy hole died after announcing the amazing find, and folks speculated that breaching holy grounds brought on an ancient curse. Thankfully, the cave is now guarded under lock and key and can be seen only with special permission.

Still another haunted holy hole was the Weeping Maiden's Cave, located in Garfield County. This hidden fortress served as sanctuary to the White River Ute Indians for centuries. In this sacred womb of the earth, Ute mothers gave birth to their offspring, knowing their babies would be specially blessed by the gods. Within this hallowed sanctuary, shamans held religious ceremonies and performed war dances. At the end of the year, high carnival was held, and there was a great deal of feasting and subterranean merrymaking. Then one day, a terrible tragedy unfolded in the sacred chambers, and the cave was forever blemished by the horrific episode. Adding to the mystery are whispers that the cavern is still haunted!

The saga began in the spring of 1840, when the Hudson Fur Company sent trappers to the territory, seeking sleek beaver pelts (known as "black gold" because of their great value). To the inquisitive Indians, the furry white man was a strange curiosity, and they studied him from a safe distance until they trusted that friendship could be forged. After a while, the mountain men began trading staples with the natives in exchange for animal skins. The Utes became intrigued with a yellow-haired, blue-eyed loner by the name of Jack Marcum. No doubt, they were impressed with Jack's tall, muscular physique; athletic prowess; and remarkable hunting skills. The Indians soon idolized the buckskinned mountain man and eventually accepted him as their bronzed white brother.

The Weeping Maiden's Cave is well hidden. *Author's photograph.*

The chief had a beautiful daughter who was betrothed to her father's successor. However, just before her wedding, the Indian princess fell deathly ill. The tribe's medicine man was called, but his trusty bag of tricks failed to work its magic. As the Indian maiden hovered at death's door, Jack kindly nursed her back to health, and love soon blossomed. The princess begged the mountain man to save her from the arranged marriage. So, on the eve of her wedding, the duo stole away by light of the moon. Upon reaching the holy sanctuary, a shaman joined them in marriage. When the Ute chief learned of his daughter's deceit, he was understandably outraged. The humiliated groom was also scorned by her cruel rejection, so he gathered six of the tribe's best warriors and eagerly rode toward revenge. A terrific battle ensued, and although Jack was outnumbered seven to one, he fought a good fight, strangling four Indian warriors with his bare hands. But the burly mountain man was finally restrained. Sadly, the Indian princess was forced to watch as her husband was stripped of his buckskins, scalped and tortured without mercy. After witnessing the horrific murder, the prideful princess refused to return home with her cruel captors, so she, too, suffered the same brutal fate. As a final insult, the defiant trio left the butchered bodies for the coyotes and then triumphantly rode back to camp with Jack's yellow scalp dangling from a spear.

When the Ute chief learned about the senseless murder of his only child, his grief was terrible to behold. In retribution, he ruled that the colorful paintings be seared from the limestone walls of the cavern and all the holy relics removed. The chief's final wishes were carried out, and the White

River Utes cursed the holy sanctuary forevermore. On August 7, 1889, the *Leadville Herald* captivated its readers with the intriguing headline:

WEEPING MAIDEN'S CAVE
The Cave at Sweetwater Lake
Once a Place of Worship for the Ute Indians
A Horrible Crime Committed

Not long after the tragedy, screams of the dying Indian princess could be heard emanating from the abandoned sanctuary. Once early-day pioneers came along, they learned the legend about the haunted fortress, and it soon became known as the Weeping Maiden's Cave. Even today, the haunted holy hole is rumored to be cursed by the wails of a dying woman. Nature lovers intrigued by the macabre still enjoy visiting the spook-riddled tomb. Just follow the southern trail that leads from the lake for about one mile until you reach a wooded gulch and then listen for murderous cries of a shrieking woman. Inside the mysterious cavern, you can observe the bloody red and smoky black stained walls and consider the eerie legend. Alas, if only walls could talk. But perhaps in Colorado's haunted caves, they do.

Spirits of the Underworld (Silverton and Leadville)

If only your foresight was as good as our hindsight.
—Anonymous

Colorado's mountains are riddled with old mines, and many are believed to be haunted. Mining men were a superstitious lot, especially those who came from Cornwall, playfully known as "Cousin Jacks." Along with centuries of experience in hard rock mining, Cousin Jacks brought some rather peculiar traditions. For example, whenever rodents dashed for the exit, Cousin Jacks knew to quickly follow because catastrophe was imminent. Whistling was also frowned on because musical vibrations were thought to cause cave-ins. The first indication of impending doom was usually the sound of rapid knocking or ticking. Miners came to believe that this was a warning produced by supernatural dwarflike creatures known as tommyknockers.

Known to be capricious, these tyrannical beings entertained themselves by stealing gold nuggets and blowing out lanterns. But the most insistent

superstition of Cousin Jacks concerned the taboo of females entering the underworld. Cornishmen believed that long ago, there was a race of seductive sirens that lured men into their underground dens with haunting songs. It was in these mysterious caverns that the vile vixens bewitched the miners and made them forget all about their loving families. The gods eventually punished the femme fatales by turning them into pillars of coal. Afterward, the shameless hussies escaped from their carbonized prisons in the form of poisonous gases, hoping to suffocate the miners and keep them in the underworld forever.

Female ghosts were also a serious concern. In the spring of 1879, local newspapers reported a female spirit haunting the New Discovery Mine, near Leadville. The beautiful phantom, with flowing locks of red hair and a gossamer funeral shroud, was often seen floating through the tunnels and heard moaning with terrible woe. On several occasions, the miners attempted to capture the spirited phantom, but she always managed to evade them by spitting fire and floating beyond reach with a wicked laugh. News of the wicked wonder spread like wildfire, and newspaper boys on every corner screamed, "Extra, extra, read all about it: Fire-spitting ghost in Colorado torches and scorches miners in Leadville!"

Soon, it seemed that every mine in Colorado was haunted by some kind of diabolical spirit. Not only were there fire-breathing phantoms, but there were also gurgling ghosts dangling from ropes and swashbuckling spooks riding buckets up and down mining shafts. It wasn't long before Colorado's underground became known as a paranormal playground. One day, Edward Ennis, a Scottish millionaire, got the bright idea to harness the ominous powers of these supernatural beings for profit. In 1875, Ennis hitched his wagon to a star and ended up in the San Juan Mountains, near the mining camp of Silverton. His mine became known as the "Highland Mary." Edward believed he could communicate with spirits who would lead him to a "lake of gold." The burgeoning spiritualist prayed daily for direction from his ethereal guides and then instructed his employees where to dig according to his prophetic visions. At the drop of a hat, the Scotsman could consult with ghosts by easily going into a trance. The soothsayer would squeeze his eyes shut until he shook with powerful might, sweat pearled on his brow and veins bulged from his trembling temples. After these intense psychic sessions, Eddie always told of enviable astral journeys to exotic ports of call like Melbourne, Hong Kong and Honolulu. Accounts of his mini psychic vacations were always amusing, especially when he told of meeting dead celebrities like wise old Abe Lincoln or the flirty Marie Antoinette.

However, the miners often joked that digging by divination created a series of haphazard tunnels that were as crooked as a witch's broom. Sadly, Eddie died in 1900 at the county poorhouse, a victim of insanity. But was Eddie Ennis really nuts? On June 29, 1905, headlines for the *Denver Post* caused pause for thought:

SPENT ONE MILLION
TO FIND LAKE OF GOLD

When the Ennis Brothers Became Bankrupt,
Practical Mining Took Hold of the Highland Mary
And Developed a Bonanza.

Believe it or not, the predicted lake of gold was discovered just a stone's throw away from where Eddie predicted it would be. Ironically, the new owners located the elusive fortune by consulting with spirit guides, who were obviously more in-the-know than the mystical beings that Eddie employed. Supposedly, the late discovery still excited the ghost of Edward Ennis, who was seen for many years after his death peacefully floating around the Highland Mary. Perhaps the flying Scotsman was on the best of all celestial journeys!

However, out of all the haunted mines known in Colorado, the Moyer Mine, near Leadville, is the most notorious. From its early beginnings, it suffered terribly from its dubious reputation. After it first opened, a dozen men were crushed to death, and their broken bodies were left buried in the rocky tomb. However, the dirty dozen were known to be helpful spirits who often warned of impending doom, but not everyone took the ghostly warnings seriously. On February 3, 1900, headlines for the *Cripple Creek Morning Times* announced the unbelievable news:

GALLAGHER IS KILLED
Senator from Clear Creek Meets with Fatal Accident

The Colorado state senator was part owner of the Moyer Mine but always scoffed at rumors of its legendary ghosts. One fateful day, the congressman was patrolling the tunnels when a banshee floated directly in front of him, trying to gain his attention by waving her wispy arms and pointing a bony finger in frantic warning. However, Mr. Gallagher pushed the ghost aside—only to be killed in an explosion that the phantom was protecting him from. Not long after the ominous accident, Gallagher's ghost became

lord of the underworld at the Moyer Mine. However, the stubborn senator's disembodied spirit wasn't as cordial as the others; in fact, he was downright hostile. Whenever a miner got lost, he would always be discovered with Gallagher's pick struck through his head. One time, a missing miner was found at the end of a forgotten tunnel, digging with bloody fingers and saying he had to find "the light." Apparently, Gallagher's ghost had stolen his lantern, and the miner spent the entire day following the ghost on a wild goose chase through the underground maze. Adding to the mystery were many formal reports about Gallagher's ghost that were hidden from the public. The written evidence was found several years after the mine closed, when two teenaged boys broke into the abandoned manager's hut and snooped into personnel records. At the top of each employee's file was a note card indicating why his contract was terminated. A few files had normal excuses, such as the miner moving away or desiring higher pay. However, the most common cause was simply stated with just two frightening words: "Gallagher's ghost." Even today, old-timers in Leadville warn that the old abandoned mines are not only dangerous to explore but also still haunted by legions of vindictive spirits. Old-timers warn it's best to let the dead rest in peace—otherwise you might end up with a pick in your skull!

SECRETS OF BUCKSKIN JOE (ALMA AND FAIRPLAY)

Nothing is so burdensome as a secret.
—French proverb

Galloping historians live for road trips, especially in Colorado, where enchanting reminders of our state's Wild West history liberally dot the landscape. Especially beguiling are the abandoned ghost towns and long-forgotten pioneer cemeteries. Oftentimes, old boneyards are the only reminders of once thriving communities. A perfect example would be Buckskin Joe. All that's left of the old ghost town is its charming cemetery, which was later shared by the nearby mining camps of Alma and Fairplay.

The pioneer graveyard is tucked under sweeping ponderosa pines and whispering aspens that hover over decaying monuments like loyal sentinels. The ancient memorials linger as silent witnesses to a bygone era long romanced about in dime-store novels and spaghetti westerns. Ravaged by time, some of the markers have lost their secrets to the winds, while others still share

heartbreaking sentiments about the deceased. Finding a tombstone honoring the saintly attributes of the dearly departed is quite common. But so are shameful markers declaring the dead as dreaded cheats, liars and tattletales.

Erik Swanson was the Buckskin Joe cemetery sexton for thirty years before opening Rimfrost Antiques with his wife, Beth, in the nearby town of Fairplay. One of his favorite tombstones was always the one belonging to Mr. Squire Evans, whose story goes back to the mid-1800s. Evans was a gambling man—until fate threw the dice of destiny. One night, a few drunken miners bet Evans that he wasn't brave enough to swig laudanum, an opiate commonly used by shady ladies. But the macho man fooled them all when he downed the bottle and won the coveted pot. Being the generous sort of fellow, Squire Evans bought drinks for the house. But by the midnight hour, the gambler had played his last card and was seized by the angel of death! The rest of Evan's hard-won prize went to pay for his burial. Sadly, Squire Evans left a wife and three-year-old daughter behind. His cautionary tombstone reads:

Alas T'was Lost
Life's Fleeting Pleasure
Where there was made
An Unwise Wager
And With Remorse
And Deep Regret
He Lost His Life
But Won the Bet.

Ironically, after giving up his post as caretaker for the Buckskin Joe cemetery, Erik Swanson learned he was related to the unlucky gambler. His grandmother confessed their kinship on her deathbed, quipping that some family skeletons are best left buried.

If Squire Evans still haunts the old Buckskin Joe cemetery, he would be in good company. The most endearing spirit to walk among the graves is that of a veiled woman in black. Her ghost is often heard quietly weeping before disappearing into the ether. Legend tells that in 1859, a new dance hall girl from Denver arrived in the burgeoning mining camp by stagecoach. The miners were greatly anticipating her arrival, as signs had been advertising her coming appearance at the saloon. The following Saturday night, a hearty crowd of miners was dazzled by the young woman's exotic dance performance. Dressed as a harem girl, the

The ghost of Silver Heels haunts Buckskin Joe. *Watercolor by Des Matthews.*

petite brunette tantalized and teased but didn't remove her veil until the final number. The bashful beauty had a flawless peaches-and-cream complexion, and everyone agreed that she was by far the loveliest lass they had ever cast their eyes upon. The hoi polloi threw gold nuggets upon the stage and chanted in unison, desiring to know the starlet's name. But the femme fatale just batted her big brown eyes, flashed a pearly grin and skipped behind the curtain with a girlish giggle. The miners never learned the name of the bashful beauty, so they began calling her "Silver Heels" in honor of her dazzling slippers.

Not long after Silver Heels sashayed into town, a terrible smallpox epidemic swept in right behind her, and mining production in Buckskin ground to a bitter halt. One of Silver Heels' most ardent admirers was the first to succumb to the dreadful disease. Overcome with grief, Silver Heels went door to door seeking help from volunteers to help nurse the sick. The few other women in camp were obviously jealous of the brazen beauty and refused to champion her desperate cause. Undaunted by their cruel rejection, Silver Heels worked her fingers to the bone caring for others around the clock, thinking little of her own needs. After a few months, the new city of the dead was brimming with fresh graves, but at least it looked like the deadly disease had taken its final victim. Survivors raised funds to donate to the heroine, but Silver Heels had already left town. Yet the miners still wanted to show their gratitude to their beloved angel of mercy, so they christened a neighboring snow-peaked mountain Mount Silver Heels in her honor.

By 1864, Buckskin Joe had become a flash-in-the-pan ghost town. One day, a grieving miner went to the cemetery and noticed a veiled woman in black weeping by a forgotten tombstone. Hoping she was Silver Heels, he excitedly approached her but was disappointed when she rushed away. Mystified by her hasty retreat, the miner followed the mysterious mourner until the breeze lifted her veil to reveal a horribly disfigured face. A single tear rippled down her pockmarked cheek before she turned to run over the hillside. It was the last time anyone ever saw Silver Heels—alive, anyway. Old-timers claim that even to this day, the veiled, weeping ghost of Silver Heels can be seen wandering through the old Buckskin Joe cemetery. Every now and then, newspapers will recap the old legend of Mount Silver Heels, like *the Colorado Springs Gazette-Telegraph* did on May 22, 1975, with the intriguing headline:

SNOWY, CLOUD SHROUDED PEAK;
GIANT MONUMENT TO A LEGEND

The most notorious ghost of the cemetery is a rugged mountain man formerly known as J. Dawson Hidgepath. The boastful bachelor was uglier than a boil on a witch's butt, yet he incessantly bragged about being a chick magnet. But when the oldster was in his cups, he'd confess that he'd never kissed a gal or had a bath. Dawson reasoned that refraining from soap and water and saving his virginity for his wedding night only added to his manly charms. The mangy miner had the annoying habit of proposing to every gal he met, even if they were already married, engaged, still in the cradle or had one foot in the grave.

On July 23, 1865, dauntless Dawson was picking wildflowers for the preacher's wife when he suddenly slipped on loose gravel and tumbled down Mount Bross. The coroner confirmed everyone's fears (or perhaps hopes): the roaming Romeo had shuffled off his mortal coil. The very next day, Dawson's splintered remains (along with his familiar coonskin hat) were buried without ceremony. But just a short time later, his battered bones were mysteriously found in the bed of a dance hall girl. The horrifying heap was identified as Dawson by his familiar hat and appalling odor. The next morning, the bumpkin's bones were reburied, and not much more was thought of the freakish prank. Yet exactly one month later, an old widow was flabbergasted when a freakish love letter was pushed under her door—signed in blood by the dead Dawson! Adding to her horror, she spied the loathsome lothario's trademark hat resting on a pile of bones and heard sweet nothings whispered in her ear! There was no doubt it was Dawson, as she recognized his familiar raspy voice—and bad breath.

Once again, the vile Valentino was reburied, but this time a large rock was set on top of his grave. The extra effort did little good because not long after, the skeletal Don Juan was found in bed next to a befuddled laundress in Fairplay! Finally, a few stalwart miners tossed what was left of the carefree Casanova down the deep, dark hole of an outhouse privy, hoping to put an end to his tireless shenanigans. The solution worked for a while until Dawson's bones and coonskin hat were found in the back of a wagon headed for Kansas City. Even to this day, a few old-timers claim that the ghastly ghost still haunts the old Buckskin Joe cemetery. Paranormal investigators warn that you will be aware of the ghost's presence once you catch a whiff of his crappy cologne!

Time Warp Tunnel and the Haunted Woods (Estes Park and Stanley Hotel)

Trust the instinct to the end, though you can render no reason.
—Ralph Waldo Emerson

News flash: the woods around Estes Park are cursed by carnivorous mists, as well as legions of ancient spirits. But don't let that scare you away because the area is resplendent with natural beauty. The first written account of its mysteries began in September 1885, when a team of engineers went scouting through Rocky Mountain National Park looking for a new route for the railroad. The party was led by the distinguished Colonel Joseph T.

Rocky Mountain National Park. *Oil painting by Mary Bryan Waters.*

Boyd, who was the founding father of Golden and secretary to the governor of Colorado. The explorers made camp near the railroad hub of Lyons and then set out on horseback toward the village of Estes Park. Boyd was immediately drawn to a large rock wall that seemed impregnable until the men discovered a hidden tunnel. Their timid horses refused to enter the dark abyss, so the adventurous party ventured through on foot.

Once inside the dark passageway, they began hearing haunting voices and hideous shrieks of laughter. Quaking with fear, the engineers were urged to retreat, but a strange force compelled them to push forward. At the end of

the passageway, they were welcomed by a tropical paradise, which seemed unfathomable, considering the dry, arid climate they'd come from. After lunch, the curious explorers ventured into a nearby cave. Stumbling through the darkness, they finally reached a large cavern illuminated by a strange, ethereal light, and in the center of the room was a mound of twinkling treasure surrounded by human skeletons! Being a scholarly man, Colonel Boyd examined the artifacts and reasoned that it was an ancient treasure tomb belonging to a great Aztec chief. But as Boyd reached for a nifty souvenir, the earth's rumbling shook him to his knees. Suddenly, they were assaulted by blinding light, accompanied by an agonizing cacophony of horrific sounds. A thunderous voice trumpeted over the agonizing din, saying something in an ancient guttural language, likely warning, "Leave our holy sanctuary or die!" (No doubt, a few archaic cuss words were added to the mix for good measure.)

Once they stumbled out of the cave, a mysterious blue haze quickly enveloped everything in sight. Not a word was spoken as inhumane screams and growls closely followed them back to camp. But the next morning, everything was status quo, as if traveling through a time warp tunnel and being chased by hungry demons had never happened. Greedy for the unclaimed prize, the determined party spent the next few weeks searching for the mysterious rock wall, only to find disappointment. Had it all been just some sort of weird collective dream, or had they entered into another dimension? On October 7, 1885, baffling headlines for the *Rocky Mountain News* screamed:

A MARVELOUS MYSTERY
A Story of the Beautiful Saint Vrain Valley and Its Secrets,
Which Has Never Been Solved

A Walled Park but with One Entrance;
In Which Strange Things Were Seen
And Horrible Voices Heard

Mysterious Caverns with Enormous Deposits of Mineral Wealth
And Wonderful Features

By Some Apparent Enchantment
The Whole Scene Vanishes Like a Strange and Beautiful Dream

Years later, on May 28, 1911, the *Rocky Mountain News* reported that Captain Boyd's two grown sons continued the search for the time warp tunnel and

treasure cave but that they were never found. Today, armchair historians believe this mystery happened on Old Man Mountain, which is now a protected archaeological site. An ancient Indian trail surrounds the mystical mountain, and rock formations resembling two gigantic heads guard the pathway. One of the ominous stone sentinels gazes to the south, and the other looks to the north. There are also many mysterious rock mounds scattered about the hillsides.

In 1911, reporters interviewed Arapahoe Indians and learned that the mysterious piles of rocks held sacred significance and that those who disturbed them would die from an ancient curse. To protect folks from the jinx, the State of Colorado wisely posted "No Trespassing" signs around the bottom of Old Man Mountain. But according to the 134-year-old Elk Horn Guest Ranch, you can access trails to the mountain from its lodge outside Estes Park—if you're willing to tempt fate!

But Old Man Mountain is not the only place the mists have been recorded—a local known as Miner Bill also saw them hovering over nearby Mount Caplain. But Bill believed he was personally responsible for creating the weird phenonoma. Apparently, the miner was digging near his cabin when he inadvertently dug up a bed of quartz. Once the crystals were unearthed, a creepy blue fog oozed over the mountain, and he began hearing plaintive howls wailing throughout the night. When the blanket lifted, it revealed a multitude of mutilated animals littering the slopes! Bill also found strange tripod hoofprints stamped into the snow and marked onto surrounding tree trunks, which he blamed on skin walkers. These ancient Indian spirits peeled fresh hides off animals and wore them as cloaks in order to shape-shift into that creature. Although Bill seemed as harmless as a church mouse, townies thought he was crazier than a crossed-eyed parrot— especially once he began drinking and ranting about carnivorous mists. Yet locals believed Bill's weird tales were just a pathetic ploy to get attention— that is, until the old drunk wasn't seen in Estes Park for a while, and they began to worry. Finally, a search party was sent up Mount Caplain, where they found Bill's three beloved hound dogs ripped to shreds, surrounded by the same peculiar hoofprints that the enigma had warned about. Inside Miner Bill's cabin, they found what was left of the misanthrope after the mystic haze got ahold of him. At least the oldster died a hero, since he tried to warn others about the carnivorous mists. Because of the screwy old man's brave sacrifice, the nearby YMCA camp named a rock formation "Miner Bill's Spire." However, it was a dubious distinction, considering the gigantic eyesore resembled a corkscrew. But no one was laughing when, shortly

thereafter, the mists claimed yet another poor soul. On June 9, 1911, the *Fort Collins Weekly Courier* engaged readers with the bewildering headlines:

EASTERN MAN'S DEATH SHROUDED IN MYSTERY
Charles Jackson Found Dead Outside Cabin
Near Estes Park
No Signs of Violence—
Moved to Greely Last Year.

The article is quoted as saying:

> *Mr. March said he heard Jackson getting up several times during the night, but was finally awakened by what he thought was a dog growling. He looked out the door and saw Jackson, apparently in great distress. He called to him and, getting no response, put on his clothes and hurriedly went out into the yard, where he found Jackson's body lifeless...The Coroner was unable to detect any signs of violence or of suicide.*

Sadly, the mystery was never solved, and legend tells the blue mists still haunt the woods around Estes Park.

One can't talk about the mysteries of Estes Park without mentioning the infamous Stanley Hotel, perched above the quaint village. The historic lodge was the inspiration for Stephen King's bestselling novel *The Shining.* No doubt, the legendary blue mists and ancient Indian spirits were inspiration for the book, making the Stanley world-renowned for its haunts. The historic hotel was built by Mr. F.O. Stanley, who also happened to be the inventor of the Stanley Steamer automobile. He and his wife, Flora, established the luxurious resort after moving to Estes Park due to Mr. Stanley's declining health. Could spirits of the Stanleys be lingering around their former home? Employees claim that haunting piano music can often be heard drifting from the music room late at night, which they attribute to the late Mrs. Stanley's classically trained ghost. Kris Tennant and Mike Coletta, of Rocky Mountain Ghost Explorers, believe the spirit of Mrs. Stanley still hangs around, and they have posted evidence on their website. Kris caught a very detailed apparition of Flora on video, which formed from a mysterious blue mist. The mystical ectoplasm swirled into the apparition of a smiling woman with very clear features, including her double-stranded necklace. Surprisingly, the ghost looked exactly like a nearby oil painting of Mrs. Flora Stanley, including her prized pearls. However, it's not known if anyone

heard hectic howling just before the mists formed, or if mutilated animals were ever found littering nearby hillsides. But Donnie Reed, a professional clairvoyant and radio personality known as the "Psychic X Journeyman," believes that the mysterious blue mists are actually protective spirits of the so-called ancient ones. Donnie reasons that the supernatural phenomenon is responsible for suffocating many who have tramped on ancient hallowed ground. But no matter what you believe, it's safe to say that there have long been mysterious shenanigans going on in that neck of the woods!

ETERNAL SPIRITS OF OUR STATE CAPITOL (DENVER)

I'm not afraid of death; I just don't want to be there when it happens.
—Woody Allen

For many years, Colorado politicians have been harboring a deep, dark secret: our beloved statehouse is haunted. However, it wasn't until recently that accounts of its ghosts were made public, and that was only because the diabolical information was covertly leaked to the press. No doubt, the dirty little secret has been kept for many years because employees were forced to sign confidentiality contracts about not blabbing ghost stories. First of all, the haunted hill on which the colossal building is perched was once an ancient Indian burial ground until it was razed in the name of God, glory and country. Blood was spilled over the hilltop after a couple nasty Indian battles, and the waters rippled red at nearby Cherry Creek. But Brown Hill was commissioned for use as the statehouse anyway, likely because the land was acquired for dirt cheap. Mr. Henry Cordes Brown, a prolific rancher (and builder of the historic Brown Palace Hotel), donated his namesake hill to the burgeoning city of Denver, likely hoping for political favors in return. Sadly, it wasn't until after the capitol was already built that whispers of the cursed property became known and politicians realized why the land was eagerly donated. However, by that time, it was already too late. In 2005, a sneaky reporter with the *Denver Post* got the scoop on the poop of Brown Hill. Front-page headlines splashed:

> *STORIES ABOUND ABOUT COLORADO'S*
> *HAUNTED CAPITOL*
> *But tour guide says he's told to keep quiet.*

Old postcard of Colorado's haunted statehouse. *Author's collection.*

Fortunately for the inquiring public, there is one brave volunteer who wants the terrible truth to be known. He is the distinguished Mr. George Cole, and he is the go-to guy when oddballs like me call with crazy questions regarding the building's haunted history. Mr. Cole is a Colorado native with pioneering ancestors, and he jokes he's proud to be a card-carrying history geek. Like his dearly departed mother, the busy entrepreneur claims to have inherited an uncanny gift of powerful intuition, and he swears on her beloved grave that the statehouse is truly haunted. Mr. Cole isn't afraid to admit that he's seen and heard his fair share of strange happenings during the years that he's toiled away as a volunteer tour guide—and he is not alone. Many others have also seen and heard strange, inexplicable phenomena in the haunted corridors and chambers of chillers. In fact, the *Rocky Mountain News* once referred to the interior of the building as "the lining to a casket." Perhaps the reporter was passively alluding to the spooky feeling one gets while pacing its hallowed halls.

However, just as Pluto is no longer considered to be a planet, modern-day science is quickly changing, especially regarding the paranormal. There is a relatively new theory that suggests that residual spirits could be hanging around because they are tethered by an electromagnetic pulse.

This fascinating idea is based on quantum physics and is elaborated upon in the fascinating book *Ghost Hunting in Colorado*, written by Clarissa Vazquez, in which she says:

> *Quartz…can be utilized in radio and radar transmissions. Under the right conditions, it can produce an electrical charge (piezoelectricity) and transmit ultraviolet light waves better than glass. It has the physical capacity for retaining light energy that could possibly result in a residual haunting.*

Colorado's haunted capitol building just so happens to be generously adorned with various types of native stone and metal with strong magnetic properties. We also know that psychic trauma is a key factor in residual haunts and that the statehouse has seen more than its fair share of sorrows. First of all, it took two decades to complete construction because the project was delayed by many unfathomable accidents.

Perhaps the saddest story concerns an affable janitor, known as "the Jeep," who was looking forward to his upcoming retirement—but fate is a cruel mistress. One afternoon, the Jeep was standing on a railing above the rotunda, polishing a brass chandelier, when he heard haunting voices. The Jeep freaked and tumbled to his untimely death. But what the janitor really heard was only his boss, who'd shouted that he'd missed a spot. Apparently, his words echoed through the chamber, sounding like legions of evil spirits. Heartbreaking evidence of his mistaken downfall can still be seen at the bottom of the grand staircase. That's where the Jeep not only cracked his crown but also broke the third marble step from the bottom, which is still split by a nine-inch scar. Since then, quantum physicists have concluded that some people are highly sensitive to electromagnetic energy fields, which could possibly disturb brain rhythms. This could be what happened to the calamitous custodian, who still hangs around the building hoping to one day collect on his overdue worker's compensation claim.

Still another specter to haunt the statehouse is a suicidal spirit often seen on the steps leading into the west wing of the building. This residual ghost is believed to be that of a depressed young man who was tormented by demons. On May 20, 1902, headlines for the *Denver Post* blasted:

ENDED HIS LIFE
Tragic Shooting of Harry Niemeyer at State Capitol Grounds
Suddenly Jumped Up, Gazed at Old Glory and Sent Ball into His Brain

But the most horrific haunting began in 1908. While the senate was in session, a veiled woman in black burst into the chamber unannounced. With shameless conviction, the vile vixen marched up to a senator's desk, stoically retrieved a gun from her brassiere and promptly sent him over the "great divide." Yet before stunned officers could intervene, the murderess turned the smoking revolver on herself. Ever since then, a strange white mist is known to rise from the senate floor. Tour guides have been taught to coolly blame the mysterious mist on faulty air conditioners—even when this happens in midwinter. Psychics believe the misty ghost is the senator's wife and that her hated rival still haunts the basement. Apparently, a week before the murder-suicide, the playboy senator was caught playing footsy under the sheets with a woman half his age. Shortly thereafter, the young harlot was found dead in a tunnel beneath the building. Unfortunately, her killer was never found. The phantom femme fatale is often heard crying in despair and seen wandering the basement in a diaphanous gown. Apparently, she has frightened away many unsuspecting witnesses over the last century.

Perhaps the most persistent spirits to rule the roost are the bloody Espinosa brothers. In 1863, the bloodthirsty bandits ruthlessly tortured and murdered thirty-three white men in the name of the Virgin Mary. Bounty hunter Tom Tobin finally put an end to their tyranny by lopping off their noggins and bringing them to the statehouse, seeking reward for their capture. Legend tells that the gruesome trophies are still stored in the basement and that the spirits of the desperados are angry about not being given a decent Christian burial. Apparently, the sound of horses clopping around in the lobby is often heard, and its occurrence is always blamed on the so-called headless horsemen.

Recently, paranormal investigators have concluded that the residual spirits of the statehouse are doomed to be tethered there forever, due to the unusual magnitude of electromagnetic energy that pervades the building. Sean Wallace and Aurthur Mclelland of RMRIPP (Rocky Mountain Research, Investigation of the Paranormal and Photography) have jokingly explained that until the halls and chambers are stripped of their quality quartz, awesome onyx, marvelous marble and gorgeous granite, the gaggle of ghosts will invariably remain for all time. Experts estimate that the austere building would cost nearly $60 million to replace in today's economy. Needless to say, Coloradoans are stuck with their gorgeous, yet very haunted, state capitol building. But I guess that's just what they call paying for the high price of beauty.

SPOOKY WATERS

RESTLESS SPIRITS OF GRAND LAKE (GRANBY)

The boundaries which divide life and death are at best shadowy and vague. Who shall say where one ends and the other begins?
—*Edgar Allan Poe*

An old Indian legend tells that there are literally hundreds of people buried beneath the murky waters of Grand Lake, but it will never give up the dead. Grand Lake has never been dragged to retrieve the rotting corpses, but they are there, lying deep within its watery keep, preserved by eternal silence. Yes, this subterranean tomb has its deep, dark secrets. One is that the bottom of the ancient lake has never been found.

The stories began long ago, when a tribe of Utes were camped along its shores. Scouts were positioned on a large rock outcropping to stand guard over the camp below. One night, a fierce lightning storm suddenly rolled over the Never Summer Mountains, ripping through inky black skies with frightening flashes of light and earsplitting thunder. Terrified, the Indian scouts dashed from their lofty post and sought shelter at camp below. As the horrific storm raged, a warring faction of Apache and Cheyenne soldiers had already crossed the plains and ridden over the Great Divide. The deafening thunder concealed the sound of the armies' pounding hooves as they drew closer. Just when the light of dawn crept over the mountains, the raiding warriors released a symphony of arrows accompanied by a chorus of

Ute Indians at Grand Lake. *Watercolor by Des Matthews.*

screaming battle cries. Startled by all the commotion, the Utes dashed from their burning tepees like rats from a sinking ship. The chief commanded that women and children run for lakeside canoes, and they were pushed out into the raging white-capped waters. While the warriors waged a futile battle against bloodthirsty foes, their families watched helplessly from the churning black cauldron. As the brutal storm raged on, fierce arrows flew in every direction, and warriors dropped like swatted flies onto a blood-soaked battlefield. Finally, the storm cleared, and the fracas suddenly ceased with a deafening silence. Although the Utes were outnumbered by half, they amazingly won the battle—but lost the war.

The forlorn heroes gazed upon the silent waters and suddenly realized that their wives, mothers, grandmothers and children had disappeared. As the morning light kissed silent waters, a smoky mist arose from the bottomless lake. The Indians believed the mysterious vapor was the souls of their loved ones arising from the murky depths. Because the lake appeared haunted, the Utes began calling the watery grave Spirit Lake and shunned its cursed waters forevermore.

Years later, a dozen prospectors were suddenly attacked by a Ute war party near present-day Steamboat Springs. Tragically, only four men survived. Knowing that the Utes feared Spirit Lake, they hitched their wagons and headed to its remote shores, hoping to recover from the ambush in relative safety. At the lake, they buried a cast-iron Dutch oven filled with their gold under a large tombstone-shaped boulder for safe-keeping. That evening, the foursome sat around a toasty campfire, enjoyed a hearty dinner of pan-fried rainbow trout and then turned to their bedrolls, looking forward to a good night's sleep. However, they began hearing queer sounds, and whispers among them about the waters being haunted eventually woke up old Tom, who had been snoring like a log. After accusing the men of acting like silly schoolgirls, Tom tried to calm their fears by reassuring them that he was an authority on such mysterious matters as haunted lakes. The oldster grunted that the waters likely contained gas and were settling, just like his stomach was doing after their hearty late-night meal. To illustrate his point, the oldster administered a foul noise of his own making and then pardoned himself with a half-hearted grumble. However, the old man's transparent reassurances did them little good, as they could see that he, too, was rattled by the inexplicable phenomena. To calm their fears, they chatted about what they would do with their share of the golden pot. Two of them wanted to buy farmland, and another man dreamed of opening a saloon. But old Tom only wanted some peace and quiet, so he doused the lantern, saying it was time to get some shut-eye.

Was it the late-night supper that incited such wicked dreams? That night, all four men had paralyzing nightmares about dead Indians beckoning from the frozen depths of the lake. They awoke at once to hear haunting pleas of women screaming and children crying. Not a word was spoken as they lay in their bedrolls with one eye open. For hours, the men laid shivering with fear, listening to the terrifying din cut through the awkward silence. When the light of dawn finally reached over the Never Summer Mountains, the prospectors couldn't believe their eyes upon seeing strange smoky mists arising from the lake's surface. The frightful fog scared the wits out of them, and they broke camp so fast that lighting hangs fire by comparison! It wasn't until the foursome reached Denver that they realized they had hastily forgotten all about their buried treasure. For a split second, the men considered returning for the Dutch oven, but old Tom put his foot down, claiming to be an authority on such matters as escaping from haunted lakes. The oldster advised that it was smart to leave the gold behind as a token offering to the watery underworld for sparing their lives. That sound logic

made sense to the others, and so they hastened home, hoping to soon put the ill-fated excursion behind them.

Fortune hunters seeking the Dutch oven treasure is what eventually led to tourism in the area. But officials worried that Spirit Lake's haunted reputation would eventually frighten away good paying customers, so the state's largest natural body of water was renamed Grand Lake. Every once in a while, local newspapers would entice their readers with stories about the mystery, like they did on August 2, 1883, when the *Fort Collins Courier* recalled the saga with the intriguing headlines:

A HAUNTED LAKE
INDIAN SUPERSTITION ABOUT ONE OF THEIR
BATTLE FIELDS

After learning the legend of Spirit Lake from an old Indian friend, Judge Joseph L. Westcott penned an epic poem in 1882 about the tragic Indian battle called *The Legend of Grand Lake*, which reads in part:

"White man, stand and gaze around,
For we stand on haunted ground!"
So said a chief to me one day
As along the shore we wound our way

Over the years, legends about the Dutch oven treasure and haunted lake have attracted quite a few curiosity seekers. Old-timers will tell you that the pot of gold is still buried on the shore beneath the large tombstone rock—and the ghosts? Yes, they are still there, too, patiently waiting in the dark depths, longing to be released from their watery grave.

WRAITHS OF THE DOLORES RIVER (DURANGO)

A moment in time may make us unhappy forever.
—*John Gay*

Have you ever heard the old expression "she cried a river of tears"? Rivers have long been eloquently associated with the passing of time or trouble. In August 1776, the Dominguez-Escalante expedition traveled along a body

of water they christened *El Rio de Nuestra de Dolores,* which translates to "the River of Our Lady of Sorrows." Aptly named, the Dolores River has seen more than its fair share of sadness.

On June 18, 1885, a tribe of Ute Indians were camped at the confluence of Beaver Creek and the Dolores River. Warriors had left for a few days to go on a hunting party, leaving women, children and old men behind. When the hunters returned, they found their encampment burned to the ground and their families ruthlessly slaughtered for no apparent reason. A posse of white scoundrels took the blame, but they were never arrested for the heinous act, despite vehement protest from the Ute Indian agency. They say that history is written by the victors, and so it was with the Beaver Creek Massacre. Eventually, the heinous truth about the tragedy was glossed over, just as it was with the Sand Creek Massacre of 1864. The brutal massacre was one of the last to shatter harmony between Indians and white settlers. Even to this day, legend holds that you can still hear the wrathful cries of the defenseless victims who were brutally murdered on the riverbank long ago.

However, the dying screams of murdered Indians are not the only desperate cries to haunt the river of sorrows. The howls of a tortured Spanish woman, screeching like a toad on a hot skillet, are also heard along the rolling river. The wails are attributed to the legend of the weeping woman. The saga begins with a beautiful señorita that lived in the peaceful quaint village of Durango. One fateful night, the young woman eloped with her lover, knowing that deceiving her parents would forever terminate their relationship. The honeymooners moved to a tiny shack on the Dolores River, not far from their hometown. The lovebirds were as happy as two peas in a pod until the stork made several unwelcome deliveries. Sadly, dirty diapers and financial woes soon soured their marital bliss. After their fifth child was born, the rooster flew the coop, and the young mother was forced to take employment as a laundress. Knowing her charms were fading as fast as her dreams, the sullen señorita was incessantly tortured with regret but could see no way out of her miserable lot in life.

One morning, the lonely laundress was washing clothes at the river when she noticed a handsome Spaniard smiling down at her from his fine black stallion. The hombre's riding saddle was adorned with glistening silver buttons, and his britches were made of the finest linen. The next morning, the young mother spiffed herself up by weaving wildflowers into her long black hair and putting on her favorite red dress. With a pounding heart, the lovely lady eagerly ventured to the river hoping to catch a glimpse of the mysterious stranger. Much to her delight, the Spaniard was already waiting for her on the shoreline. Once

La Llorona and other wraiths haunt the Dolores River. *Author's collage.*

their eyes met, they ran into each other's arms like they'd actually planned the clandestine encounter. From then on, the lovers rendezvoused at the river every evening. But the sexy señorita never divulged the deep, dark secret that she had five little children hanging on her apron strings.

One fateful day, the señorita's prayers were answered when the smitten Spaniard finally got down on bended knee and offered her an engagement ring. After a symphony of kisses, the love-struck seductress rushed home to pack her few belongings. But what was she to do with the five little pebbles in her shoe? Inspiration struck, and she awoke her children and marched them one by one down to the river. The baby was the easiest to drown, followed by her four sleepy siblings. As she released their withered bodies into the churning waters, the laundress laughed with wicked glee knowing all her troubles were washing downstream.

The next morning, the carefree señorita ran to the river to meet her prince charming, who was already waiting for her with a readied smile. After a warm embrace, the duo elected to ride into the next village for a quickie wedding ceremony. However, just as they were about to step into the carriage, five little heads popped up from the river current, bobbing for air and screaming for help. The valiant Spaniard leapt to their rescue, but before he got to the

water's edge, the awful apparition mysteriously disappeared. Frightened by the ghosts of her vindictive children, the maddened mother let out a blood-curdling scream and leapt into the churning river of sorrows.

After villagers learned of the tragedy, they were at least gladdened that they would never have to see the wicked laundress at the river again—but they were terribly wrong. The following evening, a fisherman overheard a wailing woman and rushed to her rescue. The hero reached for her arm, but when she turned, the señorita's once-beautiful face was bloated and ravaged by death. Clumps of mud clung to her stringy, long black hair, and worms slithered from her vacant eye sockets as she laughed with wicked abandon. Stunned by the freakish apparition, the frazzled farmer bolted like a jackrabbit, and it wasn't long before everyone in the valley knew about the river's frightening night stalker.

Eventually, the young mother's mournful ghost became known as *La Llorona*, which in Spanish means "the Weeping Woman." Legend tells that the mournful mother wails with woe as she wanders the riverbank alone at night, endlessly searching for living children to drag into her watery grave. With such a menacing reputation, could it be just a strange coincidence that the Dolores River became known as "Our Lady of Sorrows"? The cautionary tale of La Llorona was told to warn children about the dangers of wandering to close to the Dolores River at night. Locals claim that even today, the desperate shrieks of La Llorona can still be heard along the shoreline, along with the wailing Indian women, as they cry an endless river of tears.

GHOST DANCE OF TURQUOISE LAKE (LEADVILLE)

...and behold a pale horse: and his name that sat on him was Death, and Hell followed with him.
—John of Patmos

On January 1, 1889, the sun was blotted from clear blue skies, the heavens darkened and death came riding on a white horse. During this solar eclipse, Jack Wilson, a Native American who was also known as Wovoka, had a powerful vision about a great Indian messiah descending from heaven on a white horse. It wasn't long before Wovoka inspired a feverish religious movement that quickly spread throughout the country. The prophet devised a special ceremony called the "ghost dance," advocating that drumming

and dancing in circles for three days without food, water or rest would spiritually unite all tribes with their ancestors, making them strong in dark times. Wovoka promised that wearing special white willowy garments would protect them from soldiers' angry bullets and that the spectacular ghost dance would cleanse the earth and vanquish all evil. The Apaches believed that when the Indian messiah came, he would spit on the American flag and then every white man, woman and child in America would drop dead on the spot. However, by the time the ghost craze hit Colorado's dance scene, the Indians were already packing their bags and heading for reservations. Yet the ghost dance still inspired hope, and quite a few legends were spun about an Indian messiah returning from the heavens. One of these miraculous stories is about Turquoise Lake, near Leadville. Long ago, the lake was known as a summer camp for the Ute Indians, who were drawn to its crystal blue waters, which resembled a cloudless sky. The Utes were called "the blue sky people" because they believed that their race began in the heavens. Legend told that the Utes would powwow once again on the shores of the mountain lake. On August 7, 1941, the *Steamboat Springs Pilot* read:

ROMANCE AND TRAGEDY OF OURAY, UTE CHIEFTON

In 1833, Ute Indian chief Ouray was born in Taos, New Mexico. On the day of his birth, Ouray's father noticed an eagle taking flight to the north and instinctually knew that his son must one day follow. Eighteen summers later, the old man surrendered his long eagle-feathered headdress and pointed his stone-tipped spear toward the vast unknown wilderness of the Uncompahgre Plateau.

The newly minted chief led his people over the mountains and into a new world far from the reach of Spanish padres. In the valleys of the Sangre de Cristo Mountains, Ouray stalked proud elk and learned to outsmart bighorn sheep. In gorges of the Roaring Fork River, he challenged great grizzly bears and polished his unwavering skills as a mastermind and great hunter. The young chief became well respected by his enemies, including the Arapahoe, Cheyenne, Comanche, Kiowa and Sioux. Over time, Ouray refined his regal, commanding presence, and the Utes worshipped their fearless leader. Proud warriors raised their spears in homage, and respectful Indian maidens lowered their eyes in reverence to their great chief.

Ouray could have had his choice of bronzed babes, but his heart was set on a beautiful Tabequache maiden by the name of Chipeta. The Indian princess

was a soft-spoken, noble young beauty—the ideal consort to the seasoned Chief Ouray. The lovebirds were married in 1859 and honeymooned on the idyllic shores of Lake San Cristobal, long before it had cozy cabins and paddle boat rentals. Nine moons later, a bouncing bundle of joy arrived, and Ouray delighted in his heir apparent. Ouray often took his son hunting and fishing, despite Chipeta's protests that the child was much too young for such dangerous things. Then one morning, near present-day Fort Lupton, Ouray and his warriors were camped on the banks of the Platte River for a hunting expedition when the chief awoke to find his precious son missing from a cold bed. For several days, the warriors searched in vain for the little Indian prince, but alas, he was never found. After much prayer, Ouray determined that the Great Spirit took his son to the happy hunting grounds because he wanted the Utes to learn a lesson in humility.

A few months later, the great Chief Ouray signed a peace treaty with the United States government, giving up most of the mountains as well as the San Luis Valley. Reserved and sorrowful, Ouray and Chipeta resigned to a life of ranching in the Uncompahgre Valley. Four years later, out of the plains of Texas came great herds of longhorn cattle, and Chief Ouray was forced, once again, to forfeit more land to Uncle Sam. The beginning of the end came in October 1879, when federal agent Nathan Meeker plowed over the Utes' horse racing track in order to punish them for gambling on ponies. Meeker had been sent to the Ute Indian agency as a diplomat. However, the Indians didn't take well to the bully and got revenge by kidnapping his wife and daughters, burning down his hacienda, slaughtering his ranch hands and running a stake down his throat. The Utes also ignited a huge forest fire that burned for several weeks, saying the smoke would make their horses run faster and farther away from the evil white man. Chief Ouray, embarrassed by the scandal, managed to act as ambassador, and all of the hostages were released unharmed; however, the die was cast. Within days, the Utes were ordered to move to a southern Colorado reservation. Perhaps it was a blessing that the mighty chief never lived long enough to see the tragic evacuation of his people, as he died soon after the new land treaty was signed.

Shortly after the honorable chief's death, medicine men had great visions of a new beginning for the Ute people. Around hopeful campfires, these mystical prophets predicted that one day a great messiah would come from the heavens to save the Ute nation—and that he would be the long-lost son of Ouray and Chipeta. When the Indian prince returned, there would be great medicine, the heavens would thunder louder than water roaring through black granite gates of the Black Canyon of the Gunnison and clouds would

The Indian
messiah of
Turquoise
Lake. *Oil
Painting by
the author.*

depart to reveal his rightful throne. The Indian prince would descend from the heavens and meet his people on the banks of Turquoise Lake, where the waters are as blue as heavenly skies. All living creatures will rejoice, and the people of the Ute nation will be forevermore masters over mountain and meadow. Even today, legend tells that you can still hear the ghostly battle cries and chanted prayers of hope as the whispering winds dance across the sky-blue waters of Turquoise Lake.

CURSE OF THE PURGATORY RIVER (TRINIDAD)

The empty vessel makes the greatest sound.
—William Shakespeare

In ancient Greek mythology, the river Styx came to symbolize the boundary between life and death. Remarkably, Colorado is home to a river with a similar legendary distinction. Adding to the mystery is that the river is known by three different names. Running through the southern village of Trinidad is the Las Animas, Purgatory or Picketwire River, depending on which sign you read. Over the water is a bridge with several bronze plaques, stating the river's various names, mounted on the railing. On the west side of the bridge is another sign that lists everyone who held office the year the bridge was erected. Surprisingly, you will have to cross to the east side to read that the bridge was rebuilt in 1905 after being washed out by a deadly flood in 1904. The river runs from Trinidad Lake, about four miles upstream. During irrigation season, the water runs fast and clear, but most of the time, it appears to be little more than a wide, muddy stream. It might make you wonder how such an insignificant-looking body of water could have so many mysterious legends associated with it.

Needless to say, the river with three names has caused much confusion. When French trappers ventured from St. Louis to trap on the river, they translated the Spanish name *Purgatorio* into the French *Purgatoire*. Finally, when American bushwhackers came along, they twisted *Purgatoire* into "Picketwire." Sometimes the thrice-named river would appear in local newspapers, like it did in the *Leadville Herald Democrat* on July 6, 1895, with the captivating headlines:

A RIVER WITH THREE NAMES
A Colorado Stream of Multiple Titles
and a Romantic History Dating
Back Hundreds of Years.

The mysterious river was first christened in the fall of 1700, when a regiment of Spaniards left Santa Fe with a treasury wagon, headed to Saint Augustine, Florida. The party was commanded by Carrasco Rodriguez, who ignored his advisors and led the party in the opposite direction. Once they reached present-day Trinidad, the captain was fit to be tied when he realized they had traveled miles off course. Obviously, there weren't as many signs posted in Trinidad back in the olden days. Like all tyrannical leaders,

A cabin on the Purgatory River. *Watercolor by Des Matthews.*

Rodriquez blamed his mistakes on the second in command. In anger, the captain picked up a rock and clobbered his lieutenant, who fell into the river with a triumphant splash. As the regiment watched the soldier's blood trickling downstream, a priest christened the waters *Rio de Las Animas*, which translates to "the River of Lost Souls." Apparently, the holy man chose the ominous name because the lieutenant was never given his last rights and his soul was committed to purgatory. Rodriquez and his soldiers wintered in Trinidad and then headed out once again in the spring. However, the doomed regiment lost all sense of direction and never made it to Florida.

Five years later, an Apache Indian was captured by Spaniards searching for Rodriquez and the lost treasury wagon. The warrior told that five years earlier, he had witnessed Spaniards wandering aimlessly along the Purgatory River but that everyone in the party had been murdered. He solemnly confessed that his tribe took spoils of battle but never saw the twelve trunks of gold doubloons. The soldiers reasoned that the treasure was buried in one of the fissures along the riverbanks. Legend tells that there is good reason why the stashed gold has never been found: it's guarded by a vindictive ghost. For over three hundred years, a spectral treasury wagon pulled by six fire-breathing black stallions storms a path to perdition along the Purgatory River during the full moon. Even more frightening is the devilish ghost of a Spaniard seen whipping glistening reins while wearing luminescent gloves that glow in the moonlight. Could this frightening apparition be the long-lost treasury wagon that disappeared long ago? In 1924, a suit of Spanish armor was found rusting on the side of the river, and gold coins were discovered by a young Mexican. However, on the teenager's way back to Trinidad, he slipped from the trail and broke a leg. Sadly, his comrades found him the next morning, knocking on death's door. But with his dying breath, the young man confided that he'd found several trunks loaded with old gold coins stashed away in a remote cave along the river. Legend tells that to this very day, the lost treasure is still waiting to be found. However, the river is still haunted by all the lost souls who perished within its grasp. Perhaps that's the reason why nobody ever searches for the long-lost treasure of the haunted Purgatory Canyon. Can you blame them?

DEEP SECRETS OF THE LAKES (COTTONWOOD LAKE, TWIN LAKES, MONTGOMERY RESERVOIR AND LAKE GEORGE)

You are only as sick as your secrets.
—Anonymous

Believe it or not, sea monsters have always been a big problem in our landlocked state. The legends began centuries ago when local Indian tribes began swapping campfire tales about the formidable man-eating monsters. But the first white man to blow the whistle did so back in 1878.

The story begins near Buena Vista with an old miner ironically known as Young Ike. The oldster had a cabin on Cottonwood Lake, where he mined the hillsides and panned for gold. The prosperous prospector believed that precious metal could easily be found wherever lightning struck. His wild theory literally came to him in a flash when he was struck by a vicious bolt. Not only did Young Ike survive the attack, but he also discovered gold beneath his feet! However, the lightning strike claimed the miner's left eyeball that fateful day—but not his sense of humor. The consummate optimist bragged that he favored his new glass eye far more than the limp lamp he'd been born with. Over the years, the oldster collected porcelain impostors from all over the world. Many in his extensive collection were custom made in Europe by skilled craftsmen trained in painting miniatures. In fact, Young Ike frequently changed his fake eyeball like an English duke would do with a silk tie or scarf pin! During the holiday season, the practical joker typically sported a glass orb depicting jolly old Saint Nicholas or the baby Jesus. He wore a rainbow trout whenever he went fishing because he claimed it brought him good luck.

One fateful morning, the old man was sporting his eagle eye when he keenly spotted the sea serpent! Ike claimed the massive monster swam to the shoreline and swallowed a fisherman before slipping back into the inky abyss. Everyone knew Young Ike had superior eyesight whenever he sported his favorite fob and that his word was as good as gold. Needless to say, it didn't take long for the alarming news to spread from coast to coast. Noted scholars came from all over the country to investigate the age-old mystery. Years later, on August 22, 1907, the *Buena Vista Colorado Republican* confessed:

WHAT THE COTTONWOOD LAKE
SEA SERPENT STORY REALLY IS

The article suggested that the bashful beast was really the ghost of a prehistoric monster known as the "Diabello Dinothesium." Apparently, these critters were attracted to rich mineral deposits, which explained its existence in Cottonwood Lake. Supposedly, the amphibious lizard traveled to other bodies of water located throughout the world via subterranean passages. Apparently, this is how the sinister sea serpent eventually left Cottonwood and found a new underwater lair at nearby Twin Lakes.

Once the maddened monster began slurping unsuspecting tourists from the shoreline of Twin Lakes, numerous letters were written to congressmen, pleading for martial law to step in. However, their collective pleas were

The sea monster of Twin Lakes is still at large. *Author's collage.*

ignored. Then, in the late 1800s, deep-pocketed entrepreneurs built a luxurious retreat across the bay from the town, despite rumors about the dreaded monster. The Interlaken became an exclusive island resort that, for a short time, rivaled the posh Broadmoor Hotel in Colorado Springs. The lodge was built to resemble a quaint Swiss château; however, it looked more like a haunted castle shrouded by the impregnable mists of Avalon. But despite its inherent lack of curb appeal, the Interlaken attracted the *crème de la crème* of high society. The esteemed guest list included the likes of Senator Horace Tabor and his gold-digging bride, Baby Doe. Yet even though the Interlaken had the finest accoutrements in the Rockies, the lodge was doomed from the get-go. Shortly after the ribbon-cutting ceremony, the

"Loch Ness monster of Twin Lakes" raised its ugly head and scared off a few bigwigs from Denver. Making matters worse was that the only way to reach Interlaken was by boat, so guests had to first cross the troubled waters in order to reach the safety of the hotel. The lodge employed two steamships to ferry guests across the spooky lakes. Legend tells that one fateful day, the boat known as the *Dauntless* was crossing the misty waters when it collided with the sea monster. The startled creature swam away unharmed, but the doomed ship sank to the murky depths. The *Dauntless* disaster occurred exactly twenty years before the *Titanic* tragedy but is still relatively unknown, likely because the catastrophe was quickly swept under the rug and the number of venerable victims is unknown. After the *Dauntless* disaster, tourism at the posh resort suffered considerably, and everyone reasoned the sea monster was to blame. However, on August 3, 1894, headlines for the *Leadville Evening Chronicle* noted otherwise:

> *The Strange Aquatic Monster*
> *That Inhabits Twin Lakes*
> *Has Not Been Seen This Year.*
>
> *A Drawing Card for the Summer Resort Hotels*
> *There Has Not Been Worked-*
> *Description of the Saurian Monster by Those Who Saw It.*

The article said:

> *A few years ago, excursionists from Leadville brought back thrilling tales of the Saurian Monster, whose tail is described as being no less than thirty feet long, with a head like the cross between an owl and a burro, a tail with a triangular prong, and huge bristles protruding from it's head, while its back is covered in by shiny scales. But this year it would seem that the famous sea serpent had crept into its subterranean cave and was there hidden from the gaze of mortal man. Parties have thought it's passing strange that such an enterprising hotel man as "Billy" Passmore, who runs the Interlaken, should not have discovered the secret lair of the sea serpent long before this and utilized him as an advertisement for the famous hotel. It has been suggested the invasion of the lakes by the new naphtha launch with its fangled apparatus and its queer propellers may have driven the monster deeper into the lake.*

Unfortunately, after only a few short seasons, the Interlaken was boarded up and soon faded into the mists of time. However, in recent years, private

grants have enabled restoration to begin at the historic hotel. Needless to say, heroic efforts are also being made to keep the lake monster at bay.

To add to our state's agony, many of our lakes are haunted, especially Montgomery Reservoir, near the town of Fairplay. Old-timers say that if you take a canoe out onto the lake, you can still gaze upon a sunken ghost town. Visible beneath the crystal-clear waters are the rooftops of storefronts, homesteads and stables, perfectly preserved for well over a century. Fishing around the sunken city is still popular, even though ghost stories have frightened off many unhappy campers. Once the reservoir waters flooded the old graveyard, ghostly apparitions of decaying body parts began floating in the lake. Fishermen often told of hooking a whopper only to lose their prize to a phantom arm playfully tugging at their line. At nearby Eleven Mile Reservoir, the old ghost town of Howbert is sunken beneath the lake, and railroad tracks can still be seen rusting below choppy waters. The haunted lake has long been known for its deadly boating accidents, which have always been blamed on hostile winds. But locals warn that the vessels were overturned by the ghost train that rumbles beneath the waters. A phantom head of a railroad engineer often pops up along the shoreline and mocks swimmers with gurgling laughter before disappearing into the ether. Sadly, over the years, the menacing demon has pulled many unsuspecting victims into the watery grave. When considering this cautionary tale, please remember that Colorado's hungry sea serpents never take prisoners—but its lake phantoms always do!

SKINNY-DIPPING GHOSTS (ROARING FORK RIVER, ASPEN AND SAN LUIS LAKES)

Great fortune brings with it great misfortune.
—Anonymous

Have you ever seen a naked ghost? If so, then you are not alone. In Colorado, there are many nude phantoms floating about, especially around rivers, lakes and streams. It's not just perverts who have seen these luminescent skinny-dippers but also highly respected citizens. Jerome Wheeler was a trusted banker and civic leader. One of his esteemed colleagues was a guest at Wheeler's luxurious namesake Hotel Jerome in Aspen. One night, Wheeler's buddy complained of seeing a naked

apparition haunting the nearby Roaring Fork River. The witness was quoted in the newspaper as saying:

Thirty feet ahead of me stood a man, naked as the day he was born; the water dripped from his limbs and he had his clothes under his arms with a pair of shoes in his hand! I knew it was a ghost, and ran over the bridge… and could sense the strange being following me…I could hear the soft patter of his feet on the plank walk as I ran up Mill Street…But as I reached the top of the hill, the patter ceased and I heard these words: "It is well that you will not come this way again at night. Now, look: I walk the air so that you may know the meaning…strange things are happening!"

Moments after the startling confession, yet another distinguished hotel guest ran into the lobby complaining of seeing the same naked phantom, walking from the river and then around the Pitkin County Courthouse. The brave businessmen knew they might be ridiculed for it, but they felt they had to warn others of the frightening apparition. The alarming news was taken to the press, and on January 14, 1900, headlines for the *Aspen Tribune* warned its concerned citizens:

THE GHOST OF THE ROARING FORK RIVER
A Thrilling Adventure of a Prominent Citizen
Between the Hours of Early Morn.

Still another naked phantom is known to haunt the San Luis Lakes, located twenty miles southeast of Alamosa. First of all, the lakes are in the infamous San Luis Valley, which already makes them subject to mystery. Locals have reported seeing flying saucers dipping in and out of the waters of the San Luis Lakes for over a century. The strangest legend about the lakes concerns Juan Carlos, a flamboyant Spaniard with cascading black hair and a curled mustache. In 1808, the mysterious Spaniard followed a star into the San Luis Valley while leading thirty wagons. The caravan held trunks filled with fine luxuries such as beautiful furnishings and oil paintings, as well as crates of leather-bound books concerning astrology, palmistry and other esoteric matters. The enigma lived in a cave until two houses could be built on each lake by hired peons. The Spaniard ran his household in a lordly way, making laborers promise not to ever speak of his abundant wealth. In one of the lakeside houses, Carlos stored immense treasure; the other, he kept as a luxurious home. Once settled, the enigma hired two dimwitted brothers to help with domestic chores. But he warned them not to ever speak about his personal affairs and sealed their lips with gold dust.

Juan Carlos's life and death were mysteries. *Author's collage.*

Juan Carlos was a devilishly handsome man: his angular features looked chiseled from stone, and his muscular physique made him resemble a bronzed god. But his piercing black eyes and deep, hollow voice made everyone tremble in his towering shadow. The way in which he overdressed was also peculiar, as he often wore velvet capes, frilly silk shirts and plumed hats, making him look like a swashbuckling pirate. However, his most peculiar habit was that every May 1, he loaded a wagon with jugs of water and baskets of sand and then headed to Mount Blanca. Like clockwork, the enigma always returned on October 31 with a wagonload of gold dust. Could Juan Carlos have had a secret mountain mine? That theory didn't seem plausible, since one man could never mine that much gold in such a short amount of time. Villagers began to speculate that Juan Carlos was an alchemist, who used sand and spring water to create gold dust. After all, the Spaniard always had money and spent it like water.

Then, one fateful night, the concerned father of the dimwitted brothers came looking for them. But the smug Spaniard claimed he hadn't seen the boys and then slammed the door in his face. Villagers knew Juan Carlos had lied, and they speculated that he murdered the brothers because they were gossiping about his personal life. But what was Juan Carlos hiding? Locals surmised the haughty

Spaniard had made a deal with the devil—after all, who else could have taught him how to make gold out of water and sand?

Surprisingly, not long after the brothers disappeared, Juan Carlos was found poisoned. The Spaniard was discovered lying on the floor of his lavish home, with all of his fine things gone, including his feather bed and silk pajamas. His treasure house was also looted. After the Spaniard's untimely death, folks claimed to see the ghost of the pompous peacock floating along the lakeshore on moonlight nights, crying over losing all his material possessions. Most of the time, he was naked as a jaybird. Occasionally, newspapers would entice readers with legends about the haunted lake, like the *Steamboat Springs Pilot* did on January 7, 1937, with the headlines:

GOLDEN PHANTOMS
Fascinating Tales of Lost Mines.

According to the article, those who previously worked for Juan Carlos claimed he was a calculating miser who buried most of his immense fortune somewhere near the waters. The theory seems plausible, since his ghost is still seen sauntering along the shoreline. Legend tells that even after three hundred long and lonely years, the sexy Spaniard is still guarding his hidden treasure. Perhaps Juan Carlos is doomed to be a paranormal prisoner of greed, despair and vanity forevermore. Sadly, there are many other skinny-dipping ghosts who haunt the shores of Colorado's lakes and rivers. But maybe that's just another good reason why you shouldn't go swimming alone—and you should always bring a camera!

UTE PASS AND THE DIARY OF THE DEAD
(CRYSTOLA AND GREEN MOUNTAIN FALLS)

There is nothing impossible in the existence of the supernatural: its existence to me
seems decidedly probable.
—George Santayana

If there were a stairway to heaven, it would likely be found in Colorado's Ute Pass. The corridor was named after the Ute Indians, who believed they descended from the heavens to dwell in what they called the "Shining Mountains." For centuries, the Utes traversed the trail to the lower foothills,

seeking the healing mineral waters of Manitou Springs. So-called prayer trees, which were once used to mark sacred trails, can still be found in the area. The old Indian footpath was abandoned in 1872, and a wagon road was blazed through, soon followed by the Midland Railroad. During the hot summer season, as many as three thousand tourists a weekend flocked to the cool relief of Ute Pass. To accommodate weary travelers, a few resort towns were quickly established. Visitors from the great beyond were gladly welcomed in Crystola, an idealistic utopia founded by spiritualists. City streets were named after biblical prophets. Eventually, these avenues were to be paved in gold, which would be mined from their land. Séances were held, seeking advice on where to dig for riches, and a series of haphazard tunnels were dug around town. In 1929, a nearby dam in College Gulch collapsed, and all hell broke loose. Most of Crystola washed away, killing one woman. (Too bad the fortunetellers didn't see that coming in their crystal ball!) Eventually, Highway 24 was paved through Ute Pass, and the summer resort towns of Cascade, Chipeta Park and Green Mountain Falls turned into quiet bedroom communities. The crown jewels of Ute Pass are a couple small community lakes with boat docks, picnic pavilions and a charming Victorian gazebo. Fishing along the idyllic shores is still popular, and ice-skating in the winter is a time-honored tradition. One day in June 2013, I was strolling around Green Mountain Falls when I happened to notice an electric orange sign posted on the town bulletin board that shouted:

FOUND: VERY OLD DIARY…FAMILY HEIRLOOM?
DISCOVERED ON 6-24-13
PLEASE CALL JAN (719) 684 - ——.

As the dog days of summer quickly passed by, the flyer slowly faded like a watercolor in the rain. Out of curiosity, I finally dialed the number and was surprised to find that I was the first person to inquire about the found book. Jan verified that the diary was authentic by noting surnames of early settlers mentioned in the journal. However, the author never reveals her own name, which made detective work more of a challenge. Jan had already spent a small fortune on hanging signs and placing notices in local newspapers. I suggested putting a free ad on Craigslist, but she said her Internet was down. I offered to place the ad for her, and we agreed to meet at the Little Pantry restaurant.

At a cozy table next to the old pot-bellied stove, we ordered breakfast and got acquainted. When I found out Jan's last name was Pettit, I nearly fell off my chair! Jan Pettit was the founder of the Ute Pass Historical Society, the

Ute Pass historian Jan Pettit holding the diary of the dead. *Author's photograph.*

director of its museum and a celebrated author. Jan has worked with the Ute people since 1974 and actually lived with them on a reservation while doing research for her amazing book *Utes: The Mountain People.* For a bona fide history geek like me, it was like meeting a celebrity. I was surprised to learn that many of the charming cabins in the area are still owned by descendants of the original owners. She said that, for that reason alone, the tightknit community is unique among all others in Colorado and joked that Ute Pass could easily be called the land that time forgot.

Once back at home, I leafed through the thin, yellowed pages of the old diary. I found it interesting to see life through the eyes of a teenager who lived a century ago. The young woman penned the little black book over a four-year period. Her family was from Enid, Oklahoma, and they owned a cabin in Green Mountain Falls where they summered every year. I laughed when the

girl told of seeing a bawdy woman smoking a cigarette in public. I cried with her, too, especially once I reached the unexpected ending. Inside the back cover was an envelope containing a pressed flower and withered photograph of a handsome young man. There was also a poem, splashed with tear stains, about a boy she loved who drowned while canoeing. Apparently, he was showing off for her and fell overboard. The lake was dragged as stunned bystanders huddled nearby. Hours later, the boy's bloated body was pulled upon the shore. Needless to say, the horrific tragedy haunted me for days. Finally, I found information that verified the tragedy through the Pikes Peak Library District. On June 25, 1923, headlines in the *Colorado Springs Gazette* lamented:

YOUTH DROWNS
IN WATERS OF UTE PASS LAKE

The article recounted how the seventeen-year-old boy was on a picnic, where he'd fished, boated and swam all afternoon. Just as the sun set over the peaceful village, the angel of death took his life just three feet from the shoreline. However, there were no leading clues about the diary's author. I was about to discard the article when I suddenly noticed the date of the boating accident—June 24, 1923—and realized the diary was found near the shoreline on June 24, 2013— the ninetieth anniversary of the drowning! I called Jan with the uncanny news, and she jokingly suggested that the legendary "Ferry Man" was to blame. I was relieved that she mentioned the old ghost story first because I didn't want her to think I was some kind of a nut job. For many years, the lifelike apparition of a young man in an old-fashioned swimming suit has been seen silently drifting in a canoe before quickly fading with the setting sun. I had always considered the popular ghost story as just another unfounded urban legend. However, once I reconsidered the evidence, everything made perfect sense. After all, many wedding ceremonies have been held along the romantic shoreline, and some couples claim it's haunted them ever since. Out of curiosity, I called on the expertise of one of the oldest ghost hunting clubs in the state, Full Moon Explorations, out of Denver, and requested an investigation. A few weeks later, lead investigator Michelle Mayer confirmed a haunting. When I gave Jan the full report, she was thunderstruck, and we both agreed that the unfathomable evidence stacked up. I asked Jan what it felt like to discover a mysterious message from the great beyond, and she chuckled, saying, "There is more in the world that we don't know than do!" I laughed, saying I'd heard that wise old expression somewhere before. But at least there is finally a reasonable explanation for the lake's legendary haunts, and so it is, in Colorado's land that time forgot.

6
LITTLE LEGENDS AND TINY TALES

Only in Aspen

You might be familiar with the classical depiction of Justice. She is classical Greek goddess wearing a blindfold and holding a scale in

one hand and a sword in the other. However, the justice statue gracing the roof of the Pitkin County Courthouse has never worn a blindfold, even after 123 years. Apparently, citizens had the statue custom made, saying justice wasn't blind in Aspen. The courthouse is also the same building from which infamous serial killer Ted Bundy escaped. If you want to know more about

The seeing "blind" Justice of the Pitkin County Courthouse. *Author's photograph.*

Aspen's dark side, check out Dean Weiler's wildly entertaining tours at AspenWalkingTours.com. (970) 948-4349

A Ghost of Boulder

When visiting cemeteries, you might notice small stones lying on top of grave markers. This Old World tradition shows that a mourner visited the grave. However, there is one grave in Boulder's Columbia Cemetery where you should never leave a rock token. The legend began in 1894, when a horse breaker by the name of Tom Horn became a hired killer for the Swan Land and Cattle Company. Tom always placed a rock under the head of the cattle rustlers after he murdered them, which became the vigilante's trademark. In 1901, Tom accidently killed a fourteen-year-old boy and was served a heaping dose of frontier justice when he was lynched. But don't even think of bringing a rock to Tom's grave, because if you do, the token will surely resurrect his revengeful spirit. Tom Horn's notorious story was featured in an eponymous western starring Steve McQueen. For more information on haunted Boulder, please see SpiritBearParanormal.com.

The Haunted Spring of Breckenridge

On March 30, 1884, the *Rocky Mountain News* featured a story about a haunted spring near Breckenridge. The Indian name of the spring is *Pau-to-creeda*, meaning "Spring of the Maiden's Curse." Legend tells that long ago, an Indian princess was captured by a warring tribe and imprisoned in the natural stone grotto surrounding the spring. One night, the princess attempted to escape by climbing the vines out of the hole; however, she fell just before reaching freedom. Her body was found lying over the spring, which poisoned the waters. Legend tells that if you drink the water, you will share the same fate of the Indian maiden. For more about the spooky haunted history of Breckenridge, please call Gail Westwood at (970) 343-9169.

More Ghosts of Cripple Creek

There are many haunted hot spots in Cripple Creek, and at least two of them have been featured on television. At the Outlaw and Lawman Jail Museum,

the ghosts will sometimes respond to commands by playing with the lights and slamming doors. Museum manager Michelle Rozell and docent Leon Drew were interviewed for the television program *Ghost Adventures*, which can still be seen on YouTube. Not to be outdone, Linda Goodman's former Cripple Creek home was featured on the Biography channel's *My Ghost Story* and can also be viewed on YouTube. Linda Goodman was a famous radio personality, author and astrologist who sold millions of books around the globe. After Goodman's death, her former Cripple Creek home was turned into a popular bed-and-breakfast. The Last Dollar Inn is known to be haunted by the dazzling redhead. Brett Leal, of Colorado Springs, stayed in the shrine-like bedroom of the superstar and caught some amazing evidence of paranormal activity known as "Linda's lights."

Fort Collins Hell Tree

One of the strangest legends about the area concerns the "Hell Tree." Long ago, a sheep farmer living near present-day La Porte was upset with one of his field hands for stealing. In anger, he grabbed the thief by the scruff of the neck and hanged him from a massive cottonwood tree. Over time, several more field workers were subjected to the farmer's wrath and ended up dangling from the Hell Tree. Finally, people in town became suspicious and demanded an investigation, but when the farmer learned that the law was closing in on him, he hanged his entire family. He then tied a noose around his neck and jumped from a lofty branch of the Hell Tree. They say that Hell Tree is still very haunted and that the ghostly visions of the murdered victims can still be seen swaying in its devilish arms during the full moon. For more information on the haunted history of the Fort Collins area, please see the book *Ghosts of Fort Collins*, written by paranormal investigator Lori Juszak and published by The History Press. Also, you can visit www.fortcollinstours.com.

Weird Manitou Springs

Proud for being weird, Manitou Springs hosts the annual Emma Crawford Coffin Races, also known as the biggest Halloween street party in the state, on the last Saturday in October. For more information about

haunted Manitou Springs, please see my haunted history tours website at ManitouLegends.com and my book *Haunted Manitou Springs*, also published by The History Press.

Mysterious Morrison

Located just south of Morrison are the Hogback Ruins, a series of large rocks formed in a U-shaped pattern. The rocks were removed from a nearby ledge long ago and deliberately set in the formation. However, there is no indication of tools being used, and it is a mystery how the rocks were moved without the use of modern technology. For more information on the spooky Morrison and Golden area, please check out Joel's Haunted History Tours at ColoradoHauntedHistory.com or call (888)-649-3849.

Phantom's Canyon

On October 10, 1929, prisoners at the Cañon City State Penitentiary began a riot in which several prisoners and guards were killed. Shortly thereafter, a prisoner wearing the black- and white-striped prison garb was spotted walking along the road to Phantom's Canyon, but when authorities attempted to capture the convict, he turned out to be a ghost. Want to learn more? The Cañon City Ghost Walk is the most fun I've ever had—with my clothes on. For reservations, please call (719) 269-3015.

Cursed Big Thompson Canyon

July 3, 1976, was the eve of the Centennial State's 100th birthday party. It also happened to be the day that the Big Thompson Canyon flooded above the town of Loveland, killing 151 people, making it the state's worst natural disaster. Some folks blamed the unfortunate timing on an ancient Indian curse. If you happen to be interested in the haunted history of the area including Loveland, Lyons, Erie, Frederick and Denver's Capitol Hill, then contact the always delightful Dori Spence of Spooks Inc. on Facebook or at Dorispence@gmail.com.

BIBLIOGRAPHY

BOOKS

Aldridge, Dorothy. *A Peek into the Past*. Colorado Springs, CO: Gowdy Printcraft Press, 1991.

Bean, Luther E. *Land of the Blue Sky People*. Monta Vista, CO: Monte Vista Journal, 1962.

Carver, Jack, Jerry Vondergeest, Dallas Boyd and Tom Pade. *Colorado Land of Legend*. Denver, CO: Caravan Press, 1959.

Dewhurst, Richard J. *The Ancient Giants Who Ruled America: The Missing Skeletons and the Great Smithsonian Cover-Up*. Rochester, VT: Bear and Company, 2014.

Dolezal, Robert. *American Folklore and Legend*. Pleasantville, NY: Readers Digest Association, 1981.

Eberhart, Perry. *Treasure Tales of the Rockies*. Athens: Ohio University Press, 1969.

Getz, Charmaine Ortega. *Weird Colorado: Your Local Guide to Colorado's Legends and Best-Kept Secrets*. New York: Sterling, 2010.

Henn, Roger. *Lies, Legends and Lore of the San Juans (and a Few True Tales)*. Ouray, CO: Western Reflections, 1999.

Juszak, Lori. *Ghosts of Fort Collins*. Charleston, SC: The History Press, 2012.

Leadville/Lake County Heritage Guide. Leadville, CO: Leadville/Lake County Chamber of Commerce, 2013.

Leslie, Darlene, Kelle Rankin-Sunter and Deborah Wightman. *Central City: The Richest Square Mile on Earth and the History of Gilpin County*. Blackhawk, CO: TB Publishing, 1990.

Martin, Mary Joy. *Twilight Dwellers: Ghosts, Gases and Goblins of Colorado.* Boulder, CO: Pruett Publishing, 2003.

Murray, Earl. *Ghosts of the Old West: Desert Spirits, Haunted Cabins, Lost Trails and Other Strange Encounters.* New York: Tom Doherty Associates, 1988.

O'Brien, Christopher. *Enter the Valley.* New York: St. Martin's, 1999.

Pettit, Jan. *Ute Pass: A Quick History.* Colorado Springs, CO: Little London Press, 1979.

Pretti, Roger. *Lost Between Heaven and Leadville: Specters, Spooks and Shades of the Departed in a Colorado Silver Camp.* Leadville, CO: Chicken Hill Publishing, 2012.

Ragsdale, Terri. *A Legend of Grand Mesa.* Grand Junction, CO: Dreamtime Press, 2010.

Ripley's Believe It or Not! Encyclopedia of the Bizarre: Amazing, Strange, Inexplicable, and All True! New York: Black Dog and Leventhal, 2002.

Schlosser, S.E. *Spooky Colorado: Tales of Hauntings, Strange Happenings and Other Local Lore.* Guilford, CT: Globe Pequot, 2011.

Smith, Barbara. *Ghost Stories of the Rocky Mountains.* Renton, WA: Lone Pine, 1999.

Stokes, Gerald. *A Walk Through Trinidad.* Trinidad, CO: Trinidad Historical Society, 1986.

Summer Rain, Mary. *Spirit Song: The Visionary Wisdom of No-Eyes.* West Chester, PA: Schiffer Publishing, 1989.

Vasquez, Clarissa. *Ghost Hunting in Colorado.* N.p.: self-published, 2011.

Waters, Stephanie. *Forgotten Tales of Colorado.* Charleston, SC: The History Press, 2013.

———. *Ghosts of Colorado Springs and Pikes Peak.* Charleston, SC: The History Press, 2012.

———. *Haunted Manitou Springs.* Charleston, SC: The History Press, 2011.

Westerberg, Ann. *Colorado Ghost Tours, Haunted History and Encounters with the Afterlife.* Boulder, CO: Johnson Books, 2013.

Womack, Linda. *From the Grave: A Roadside Guide to Colorado's Pioneer Cemeteries.* Caldwell, ID: Caxton Press, 1958.

WEBSITES

ColoradoHistory.org
GenealogyBank.com
PPLD.org

ABOUT THE AUTHOR

S tephanie Waters spent her childhood on a cattle ranch and is a fourth-generation Coloradan. She has a degree in liberal arts and has a long pedigree of yarn spinners in her family. She has been a professional storyteller for many years and is currently pursuing her doctoral degree in monkey business. "The Galloping Historian" is a card-carrying member of the Old Colorado City Historical Society. She has owned Blue Moon Haunted History Tours and Colorado Ghost Tours LLC since 2002. The armchair philosopher is also the founder and co-producer for the annual Spirits of Colorado Paranormal Convention. Stephanie was pleased as punch to contribute artwork for this project, which is her fourth book with The History Press. She was especially excited to team up with her cousin Des "Desperado" Matthews, who provided the watercolor illustrations. Desperado has been a professional artist for most of her eighty-plus years and has taught art classes in the United States and Europe. She has also illustrated children's books and designed album covers. Desperado and Stephanie have ancestors who were notorious outlaws, whippersnappers and scallywags. The country cousins share not only a shady family tree but also a love for unbridled mischief.